636.70022 NGO
Ngo, Karen.
Indognito :a book of
 canines in costume /

D0566337

WITHDRAWN

WORN, SOILED, OBSOLETE

indognito

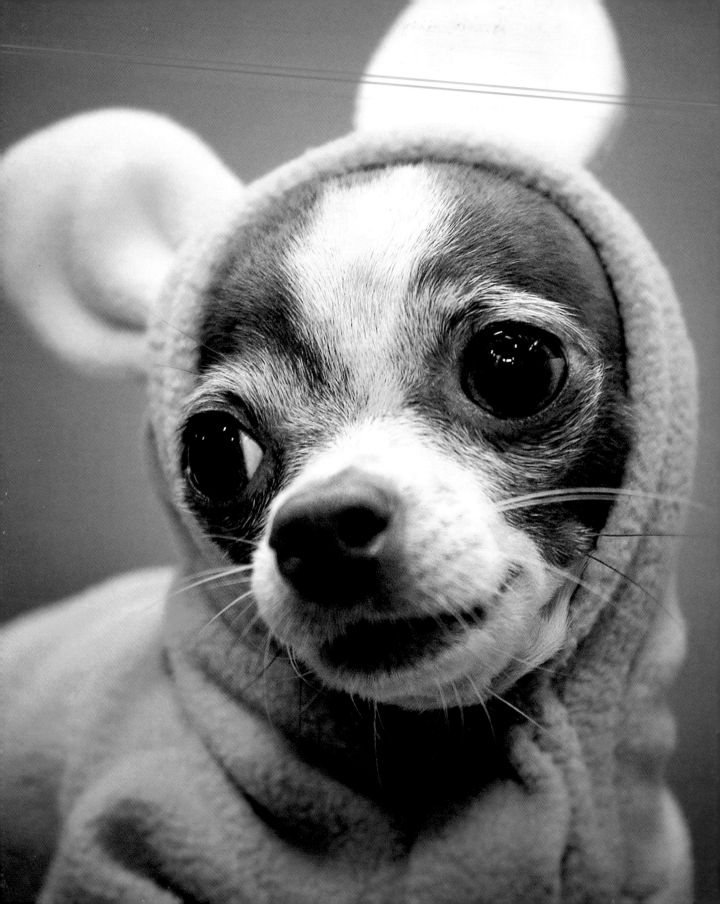

indognito

A Book of Canines in Costume

karen ngo

LB
1837

Little, Brown and Company
New York Boston London

Copyright © 2008 by Karen Ngo

All rights reserved. Except as permitted under the U.S. Copyright Act of 1976, no part of this publication may be reproduced, distributed, or transmitted in any form or by any means, or stored in a database or retrieval system, without the prior written permission of the publisher.

Little, Brown and Company
Hachette Book Group USA
237 Park Avenue, New York, NY 10017
Visit our Web site at www.HachetteBookGroupUSA.com

First Edition: October 2008

Little, Brown and Company is a division of Hachette Book Group USA, Inc.
The Little, Brown name and logo are trademarks of Hachette Book Group USA, Inc.

LCCN 2008926899

10 9 8 7 6 5 4 3 2 1

TWP

Design by Karen Ngo
Printed in Singapore

To my wonderful dogs, Martini and Emma, for bringing laughter
into my life every day and for teaching me that:

"It is a happy talent to know how to play."

RALPH WALDO EMERSON

Number of paws photographed: 224

Number of breeds featured: 28

Number of furry, dignified rulers of ancient kingdoms appearing in *InDognito:* 2

. . . of pet pioneers: 3

Number of talented, tail-wagging entertainers included in this book: 10

. . . who have fetched more than 250 million albums: 2

. . . who are constantly hounded by paparazzi: 4

Number of species who escaped from the zoo to model for these photo shoots: 14

. . . who have wings: 6

. . . who can fly: 5

. . . but not far: 2

Number of North Pole pooches who help make Christmas Eve go smoothly: 4

. . . of freshly picked pups in costume who are chock full of vitamins and minerals: 4

. . . of mutant mutts who have tussled with both King Kong and Mothra: 1

. . . of bark-worthy beings who can make all your wishes come true: 1

Number of times I said "good girl" or "good boy" during the making of *InDognito:* I lost track at around 1,429

I LIVE IN A CITY where dogs in costumes have packed social calendars. A dog's Halloween in New York City doesn't last for just one day. It runs the whole month of October with numerous Howloween parades at local dog runs and doggie day cares across the city. At Times Square's Dog Day Masquerade, hounds in disguise are broadcast live on the 1,400-square-foot AstroVision screen. At the annual Dachtoberfest, hundreds of dressed up dachshunds descend upon Washington Square Park. At Animal Haven's Doggie Drag benefit, canines get costumed for a good cause. Macy's Petacular kicks off the spring season with pets walking the runway in spring bonnets, bunny ears, and other imaginative costumes.

This phenomenon is happening all over the country, not just in New York. According to a 2007 survey by the National Retail Federation, 7.4 million households plan to dress their pets in some sort of costume, the most popular being devils, pumpkins, witches, princesses, and angels. *InDognito* came about because I photograph fashion stories with dogs and I was inspired by the clever creativity shown by pet owners during Halloween. I thought it would be interesting to explore this visual humor in a photographic character study of dogs in costumes.

The most common question I get asked is, "How do you get these dogs to pose in costumes?" It is a tricky business capturing that elusive, magical moment, all while keeping Fido from chewing his costume to bits.

This is the art of understanding what motivates each dog. Most dogs love treats . . . but which is their favorite? Baby carrots? Homemade liver brownies? String cheese? Some dogs prefer squeaky toys, or prefer being two inches away from their owner at all times. Some of my favorites: saying the name of Jack Russell Sal's best puppy friend over and over ("Where's Murphy? Where's Muuuurrrr-phy? Where is Mur-phyyyyyy?"); an owner playing the trump card by saying her dog's favorite treat ("Huevos!"); and dachshund Puck's tendency to fall asleep standing up while wearing costumes, making my challenge to keep him awake long enough to get the shot!

It's also about putting everything I learned from puppy obedience classes to good use. I always say dog modeling is a great way to train one's dog to sit, stay, lie down, and look pretty. I was so impressed with the dedication and, at times, heroic efforts of the various dog owners working with their dogs and me to create these pictures. The process really showcased the loving bond and affection between dog and owner, as well as tremendous patience exhibited by both sides.

I love dogs and I enjoy the challenge of photographing dogs because they are such honest subjects. I have many favorite images from this book, and all the dogs won me over with their sweet and colorful personalities.

I love the photo of Eli, the tiny Chihuahua dressed as a matador, who graced me with one fleeting expression of bravado. And there's Gus—who wouldn't love a pug squeezed into a plush chicken outfit? Kudos to the foxhound who gracefully, and admirably, navigated her way through a parade in her airplane costume with a six-foot wingspan. Byrd, the well-trained beagle puppy, was a pro in front of the camera at fourteen weeks old, which made sense when I found out her cousin is Uno, the Best in Show beagle. And there's sweet Bruno, the chocolate Lab turned Caesar, who figured out that his laurel wreath was not a Frisbee and learned how to balance it on his head.

My own dogs, Martini and Emma, volunteered to dress up too. Bless them. Martini is the winking genie. As luck would have it, her pink genie hat was dipping forward, shutting one eye. I vacillated as I tried to decide who should be the little angel (mischievous Martini) and who would be the little devil (guileless Emma).

Studies have shown that having pets can lower blood pressure, fight depression, and reduce stress in humans. There haven't yet been any studies on the health benefits of dressing up your dog, as far as I know. But they say laughter is the best medicine. I like to think of *InDognito* as my creative way of adding years to your life. Dog years.

—KAREN NGO

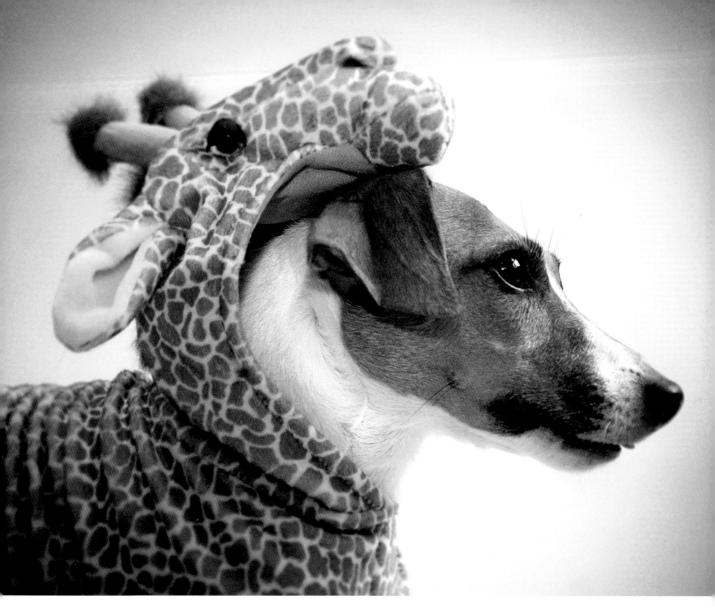

indognito

year of the dog + cavalier king charles spaniel

From Chinese astrology: one who is born in the Year of the Dog
possesses admirable qualities such as loyalty, honesty and idealism.

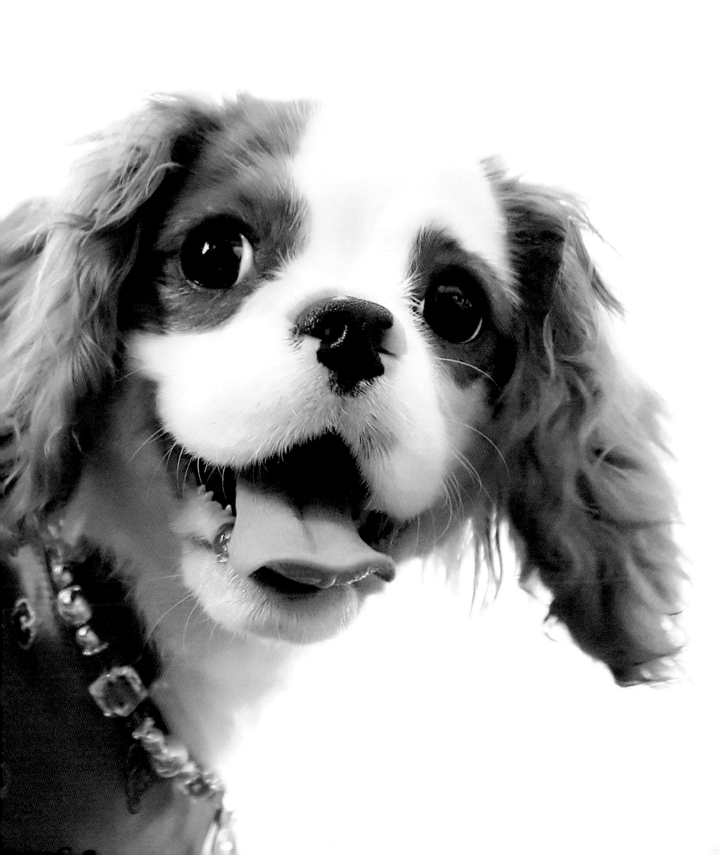

chicken + pug

"Although I cannot lay an egg, I am a very good judge of omelettes."

GEORGE BERNARD SHAW

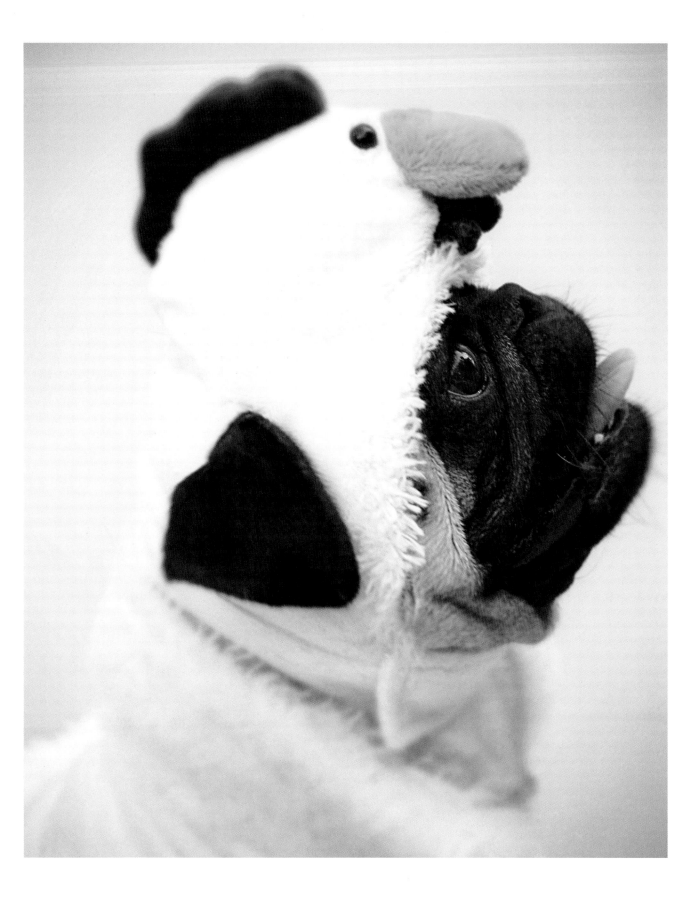

matador + chihuahua

"Clothes make a statement. Costumes tell a story."

MASON COOLEY

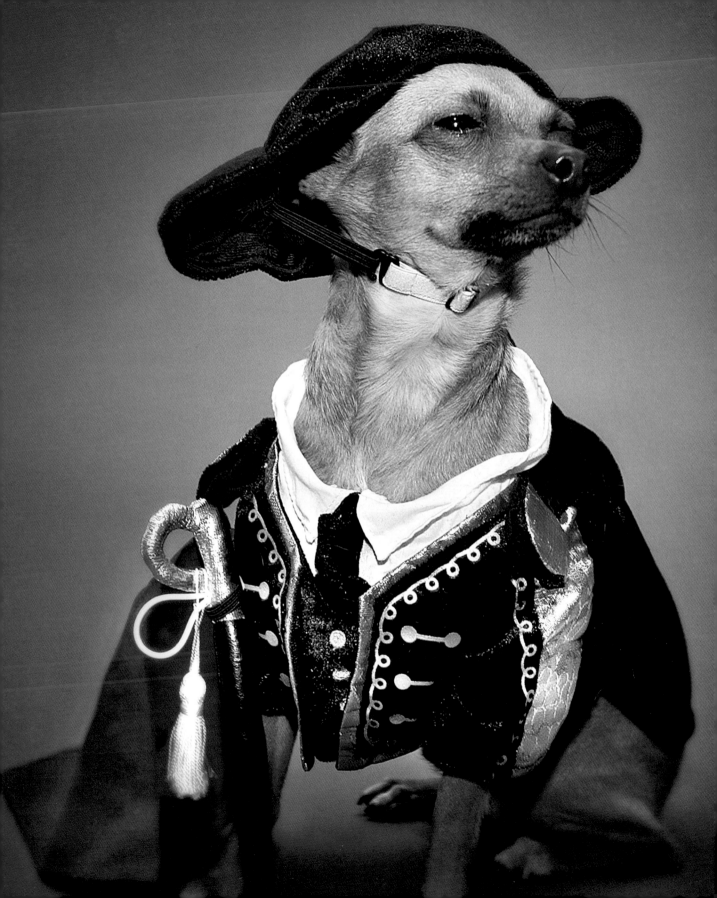

OZ + chihuahuas

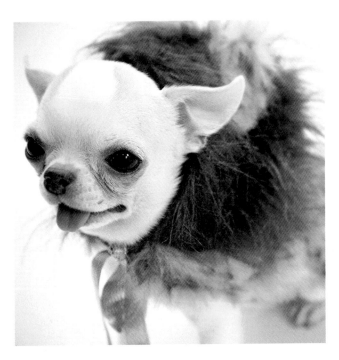
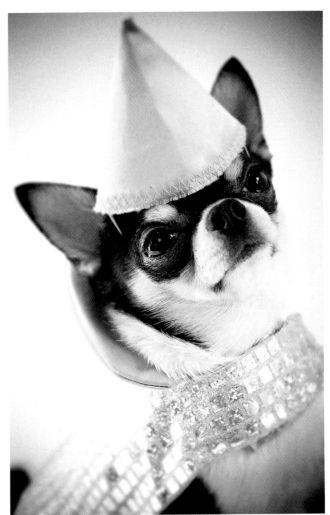

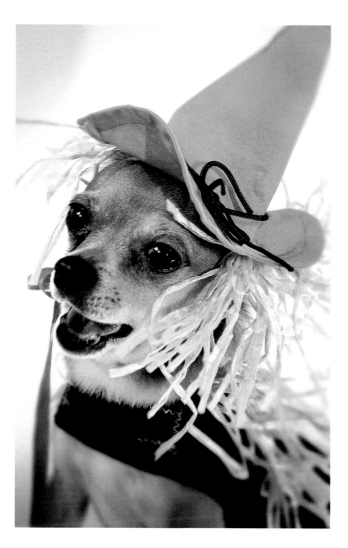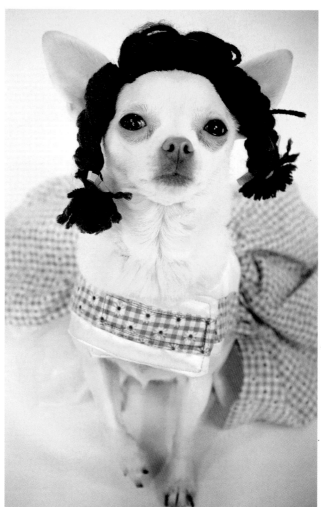

sheepish + toy poodle

"Speak softly and carry a big stick."

THEODORE ROOSEVELT

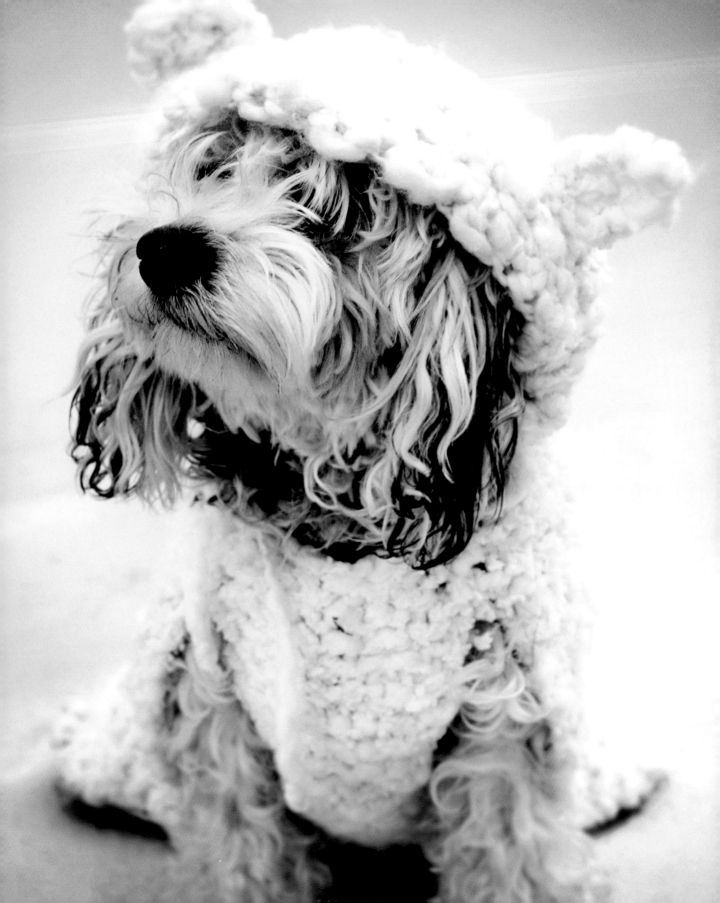

king tut + bernese mountain dog

"The barking of a dog does not disturb the man on a camel."

EGYPTIAN PROVERB

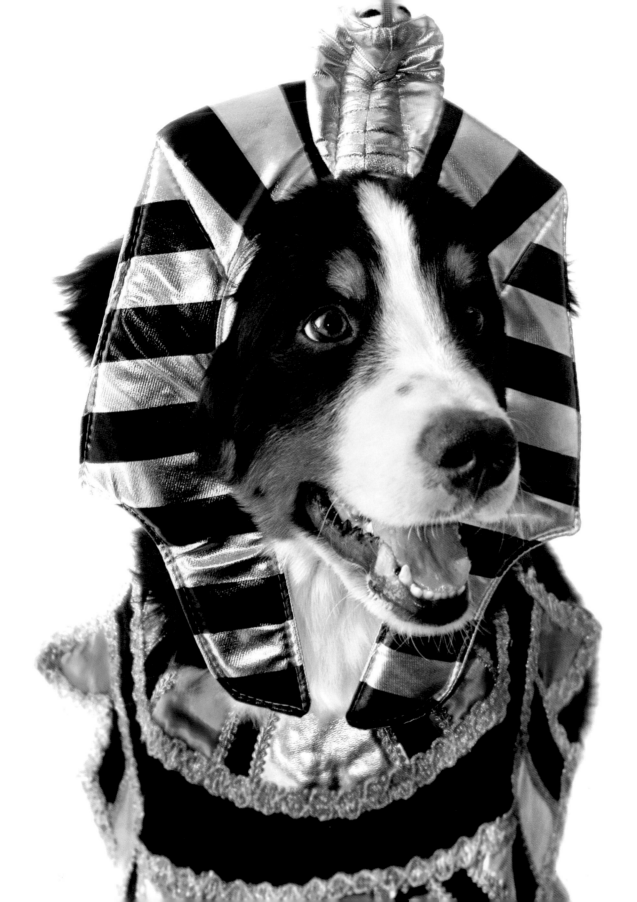

buzzworthy + pomeranian

emperor + labrador retriever

"Veni, vidi, vici. I came, I saw, I conquered."

JULIUS CAESAR

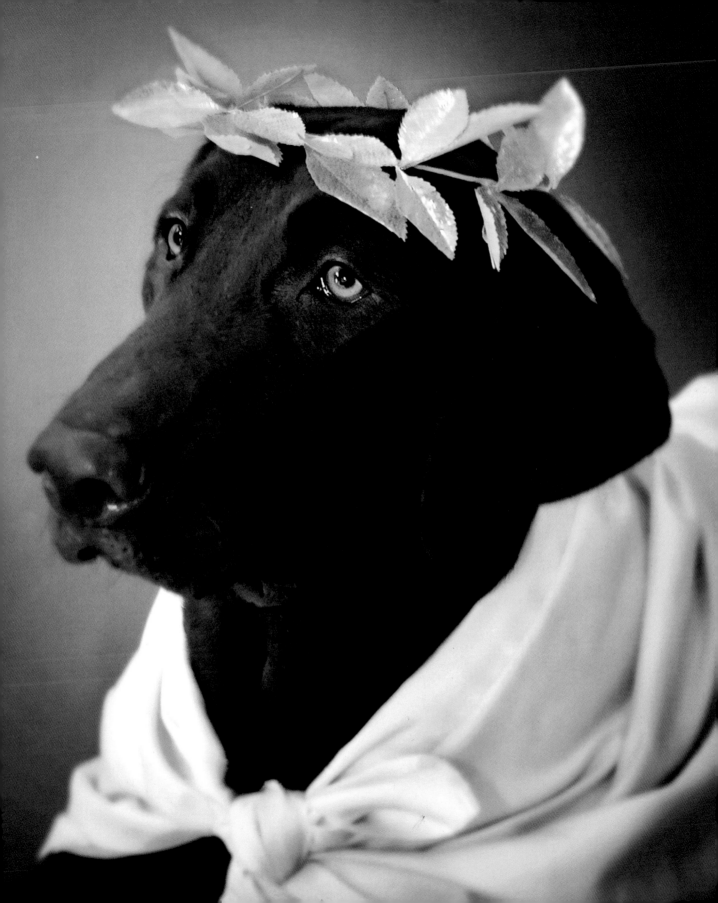

penguin + beagle

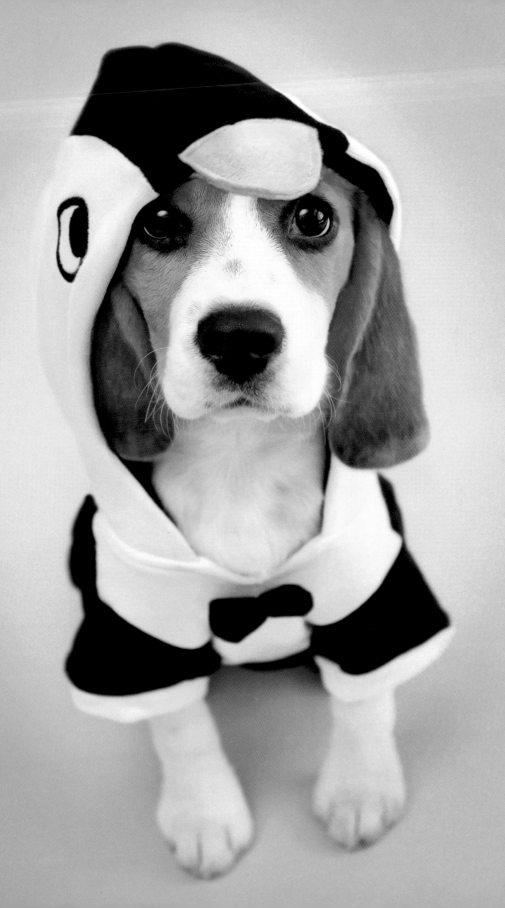

hiphop + chihuahua

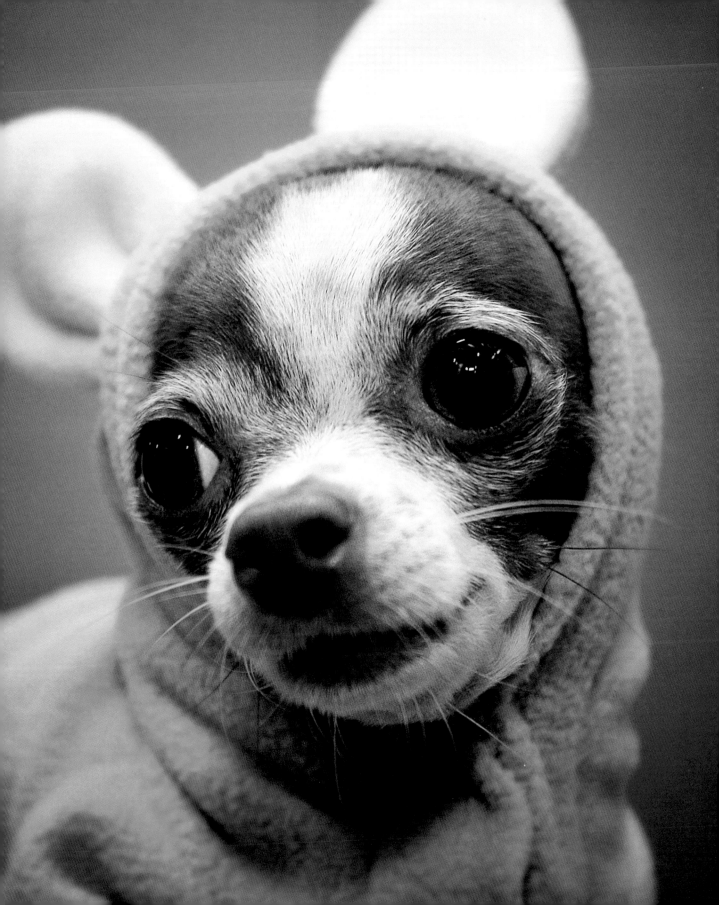

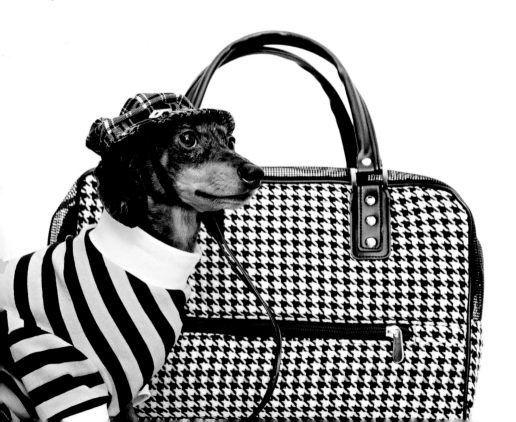

it's a mod, mod world + dachshund

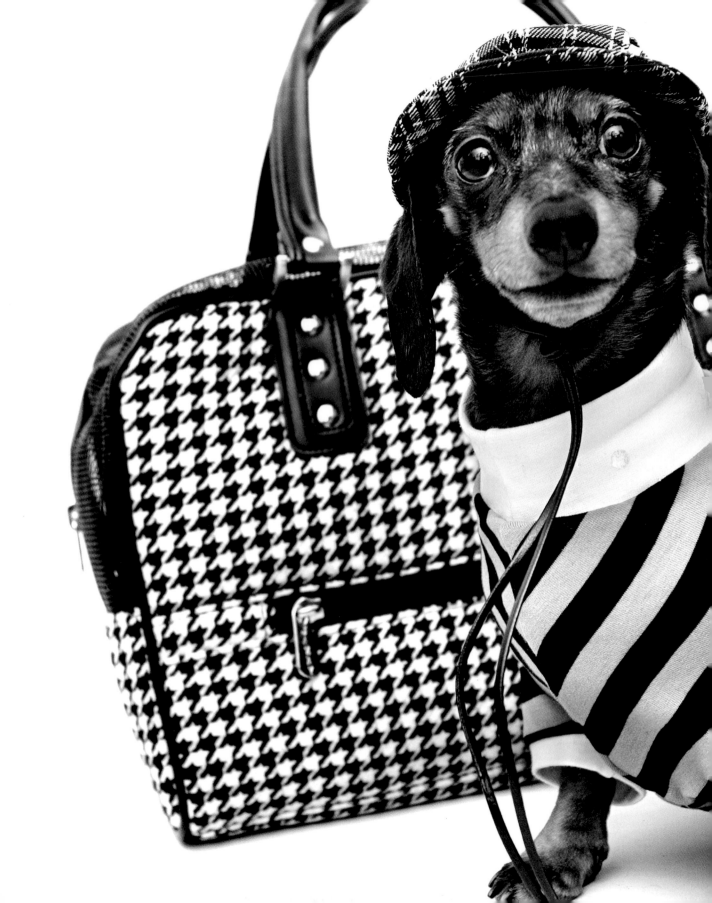

king of pop + french bulldog

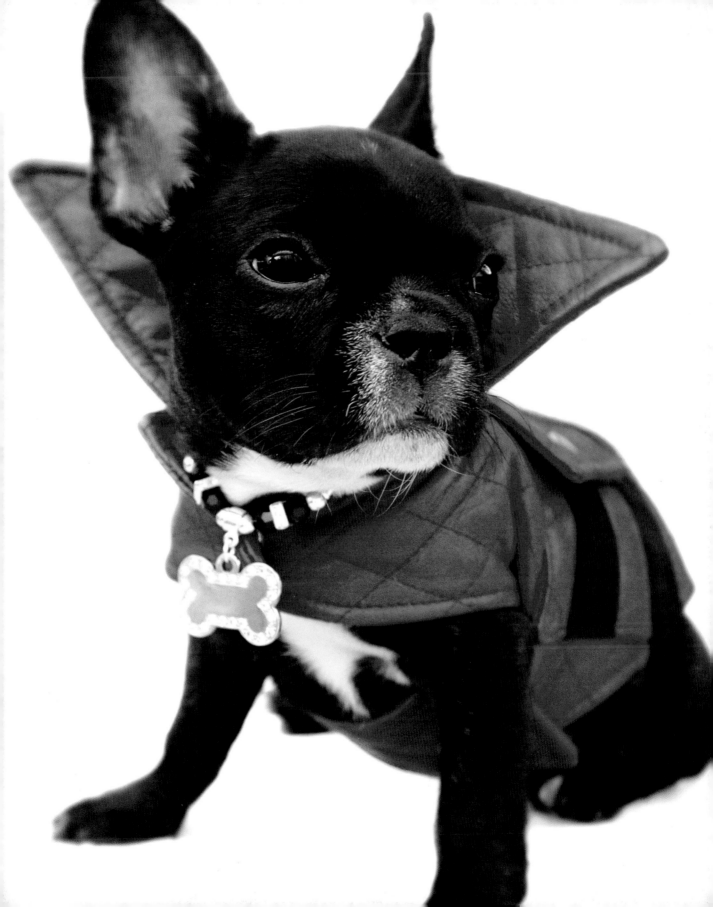

prehistoric + cavalier king charles spaniel

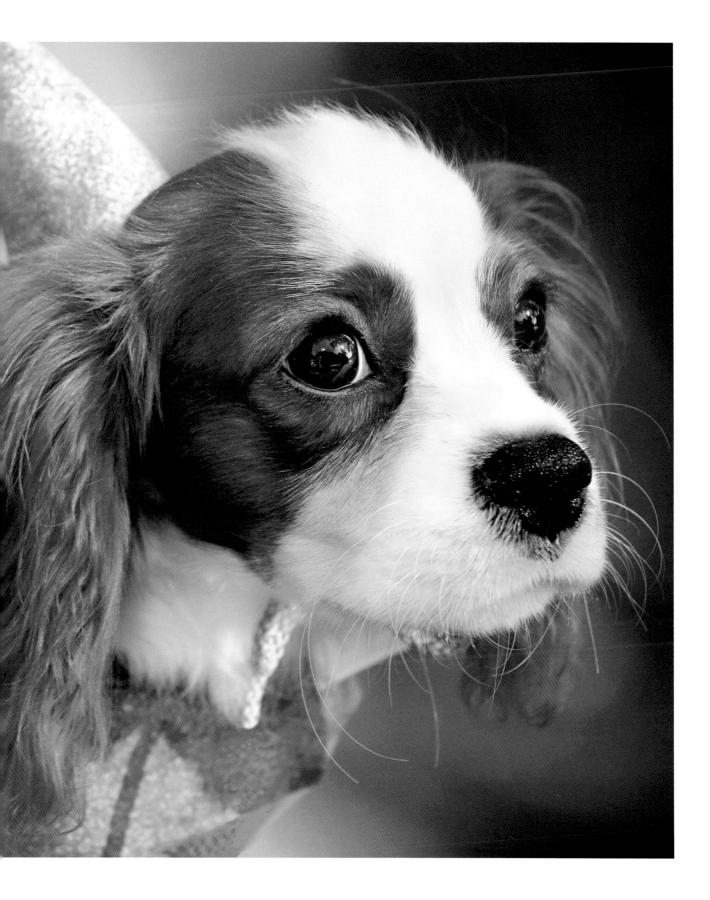

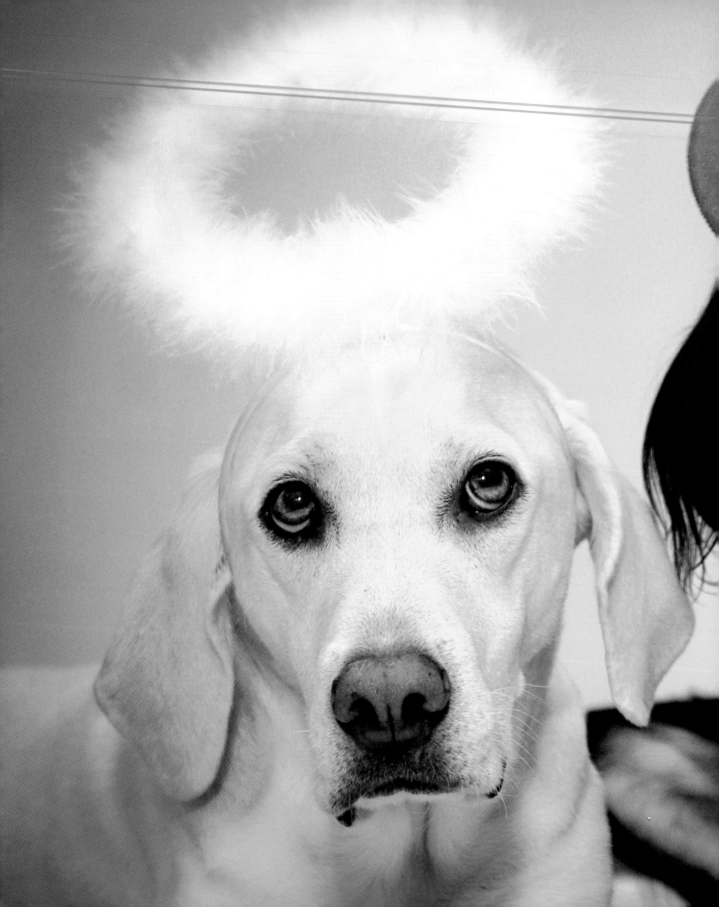

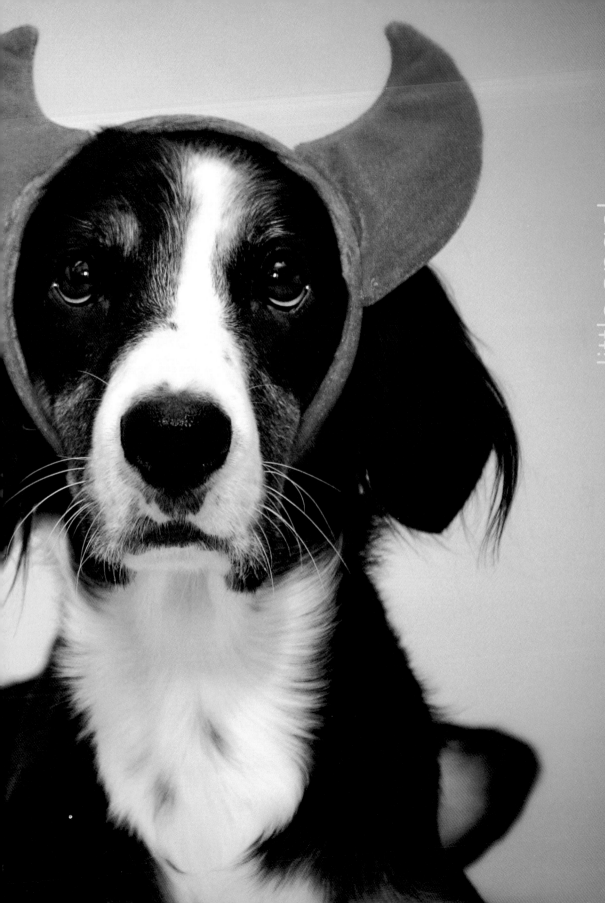

little devil
+ saluki mix

little angel + mountain view cur

rabbit + doberman

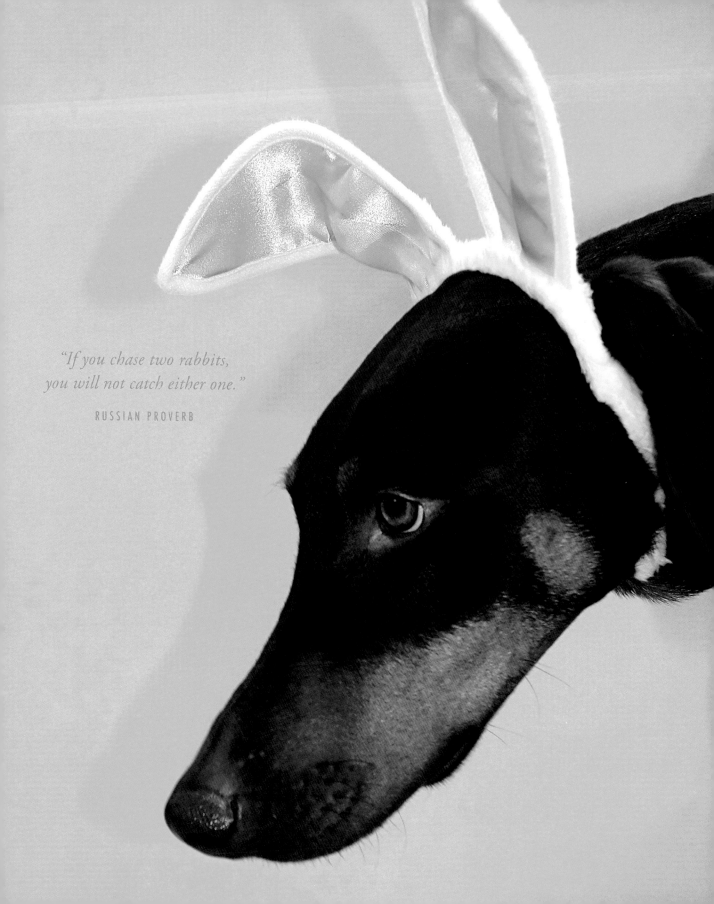

"If you chase two rabbits,
you will not catch either one."

RUSSIAN PROVERB

birthday boy + dachshund

"Birthdays are nature's way of telling us to eat more cake!"

ANONYMOUS

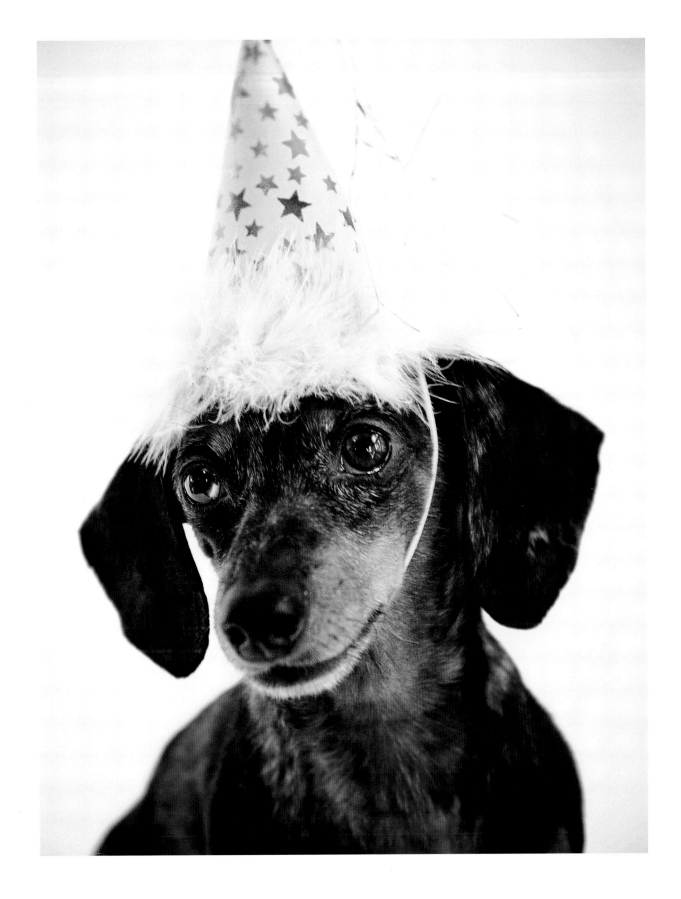

flamenco + brussels griffon

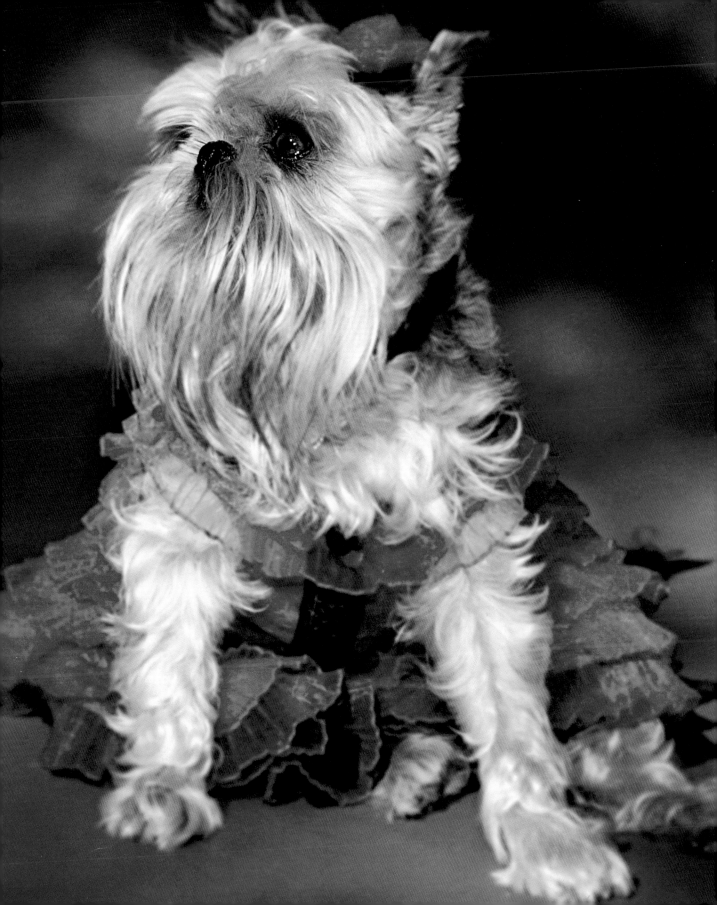

artistic genius + dachshund

"Everything you can imagine is real."

PABLO PICASSO

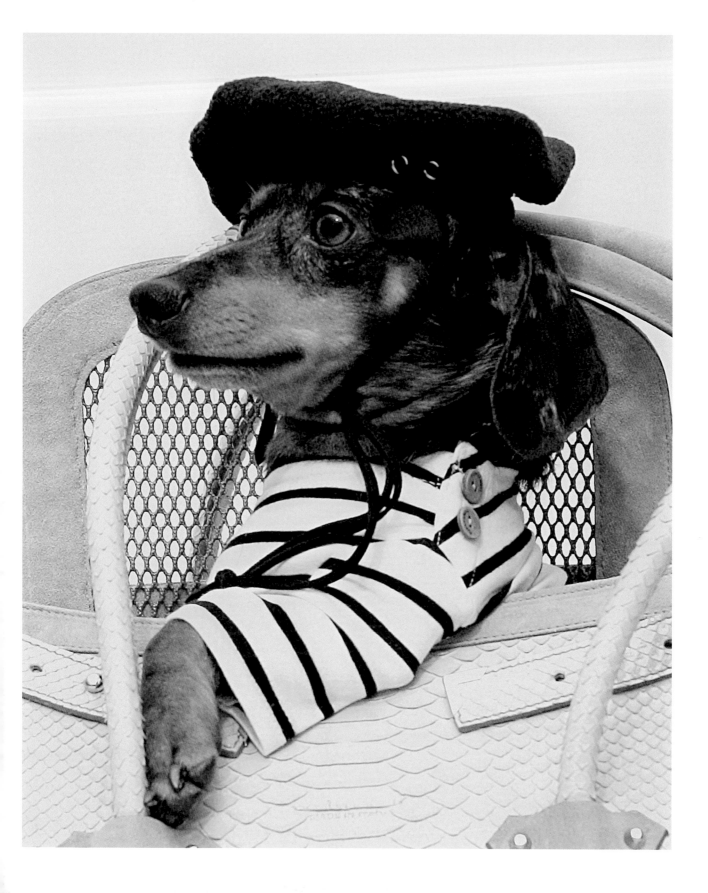

superhero + miniature schnauzer

"A friend in need is a friend indeed."

ENGLISH PROVERB

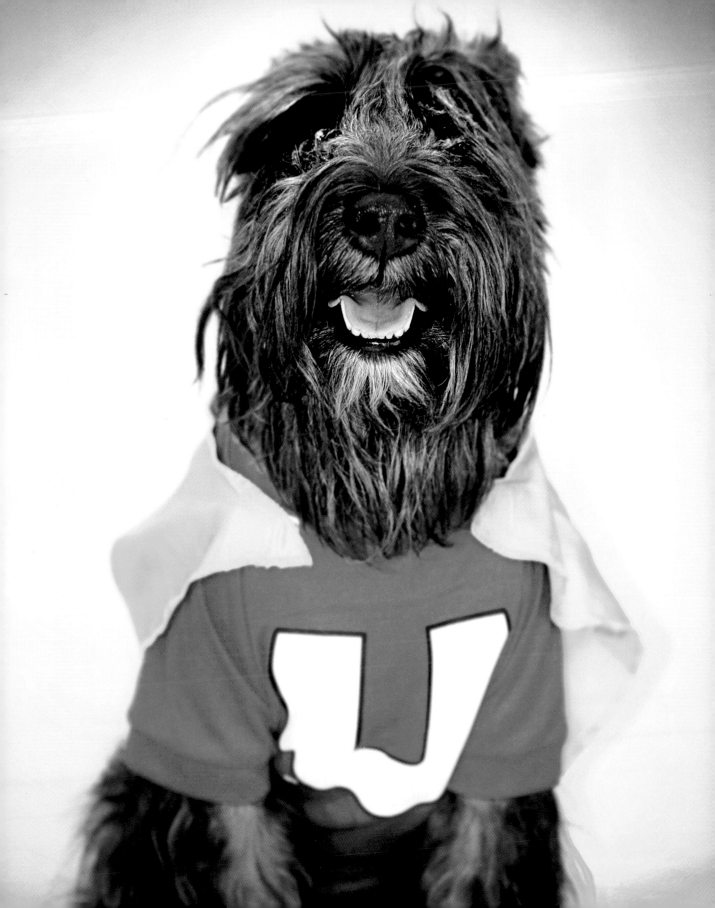

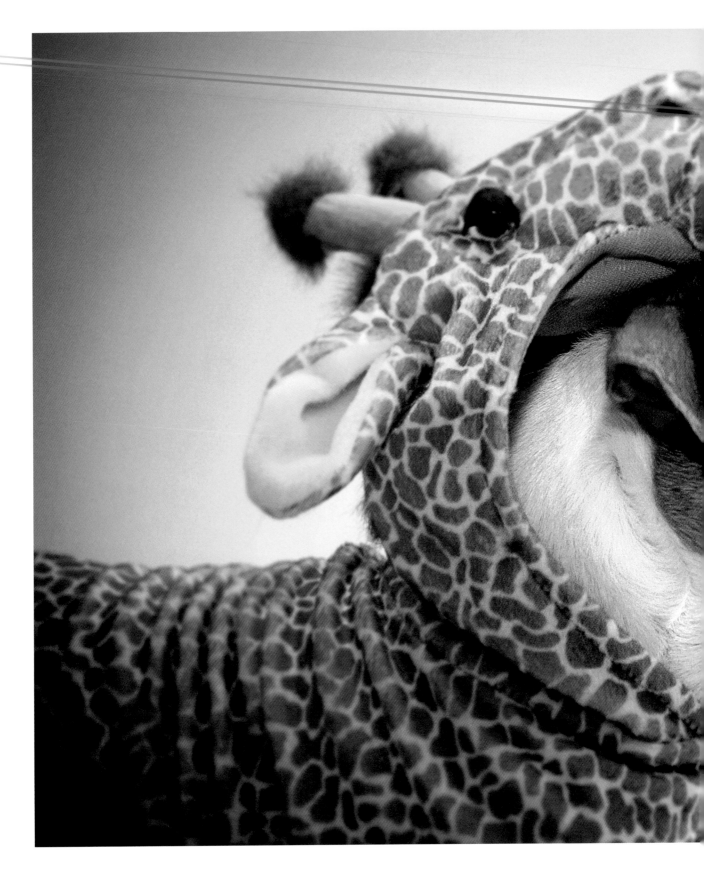

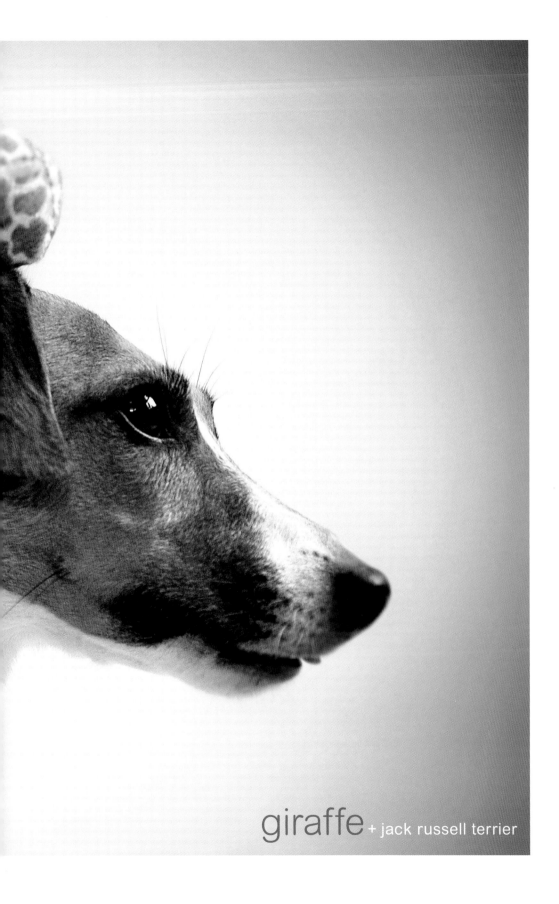

giraffe + jack russell terrier

santa's little helper + pug

"The gift that keeps on giving."

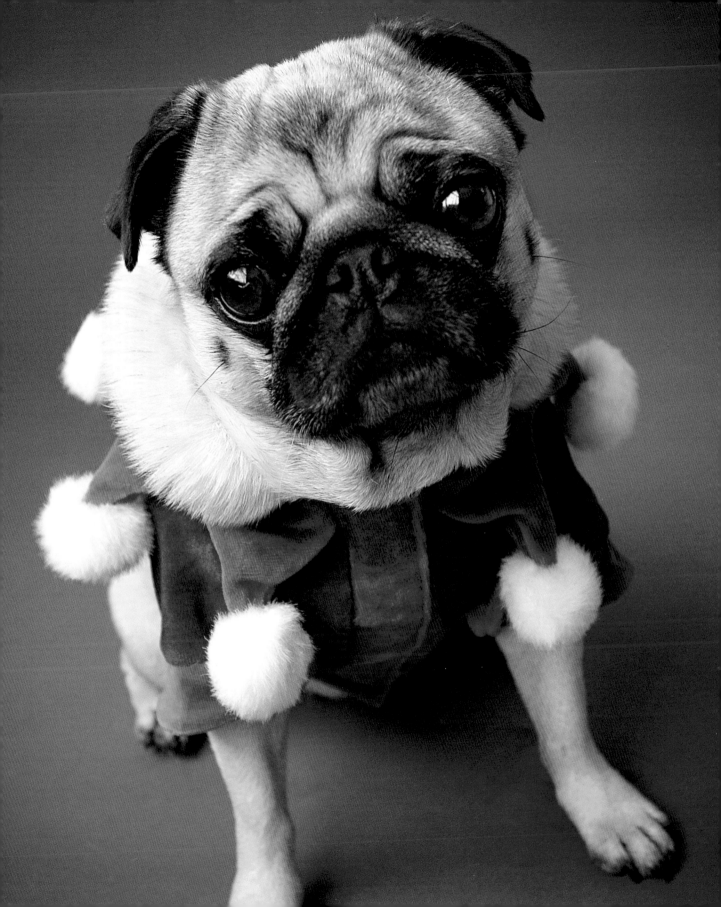

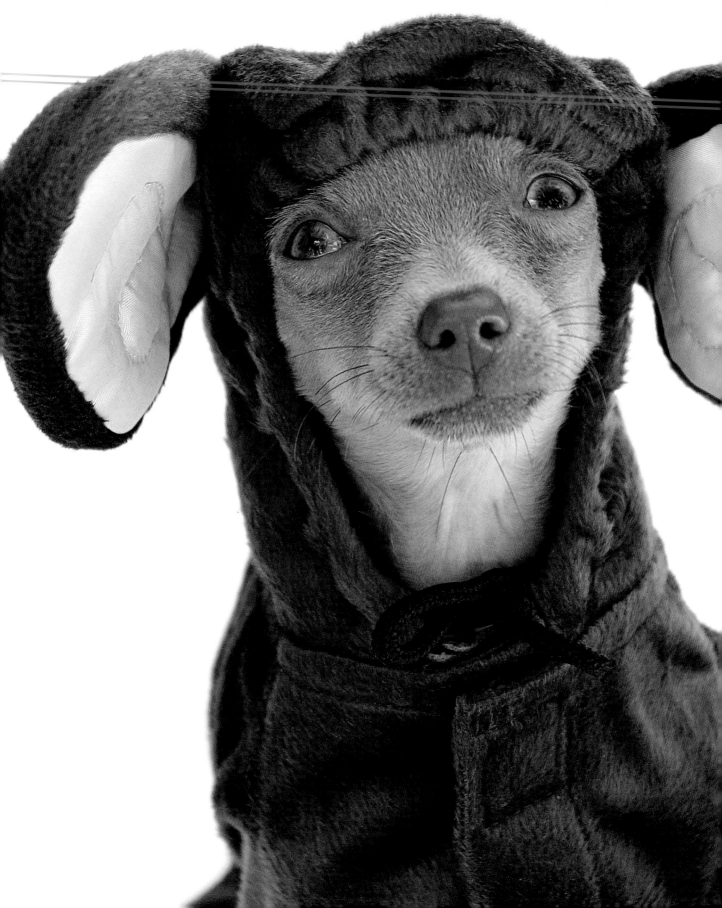

mouse + chihuahua

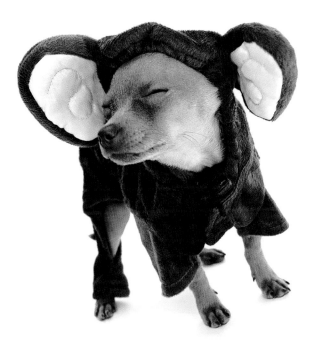

"When the cat's away, the mice will play."

ENGLISH PROVERB

ahoy, matey! + bulldog

"He who finds a friend, finds a treasure."

ITALIAN PROVERB

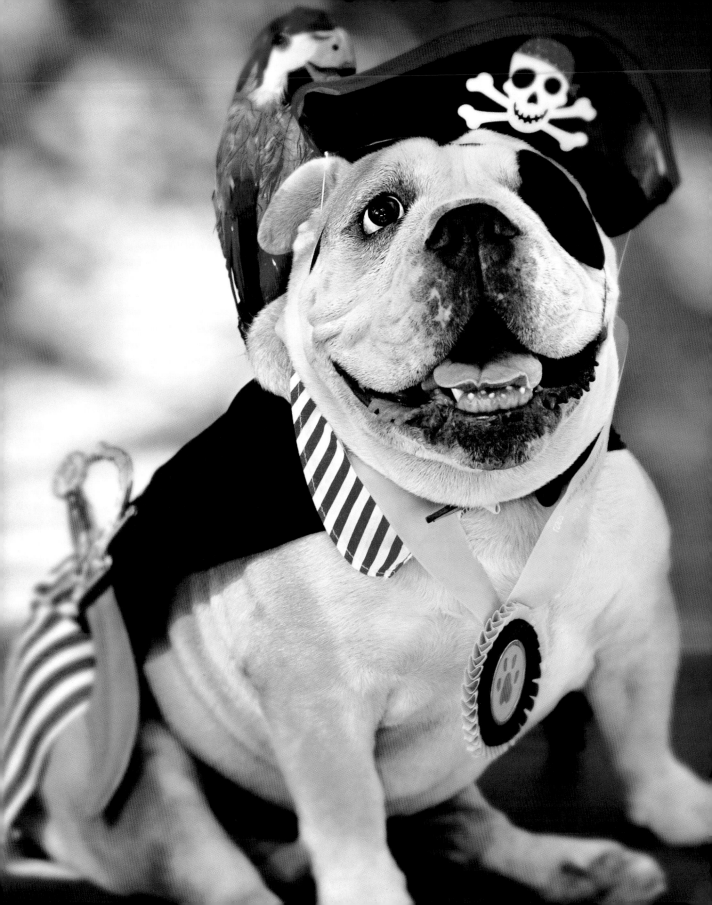

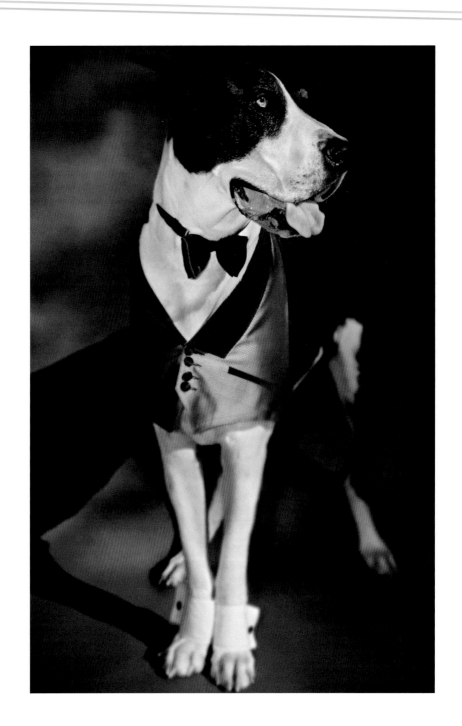

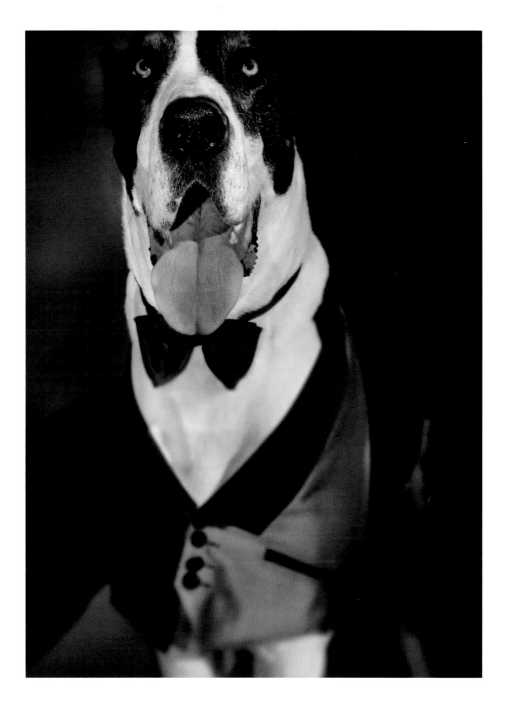

puttin' on the ritz + great dane

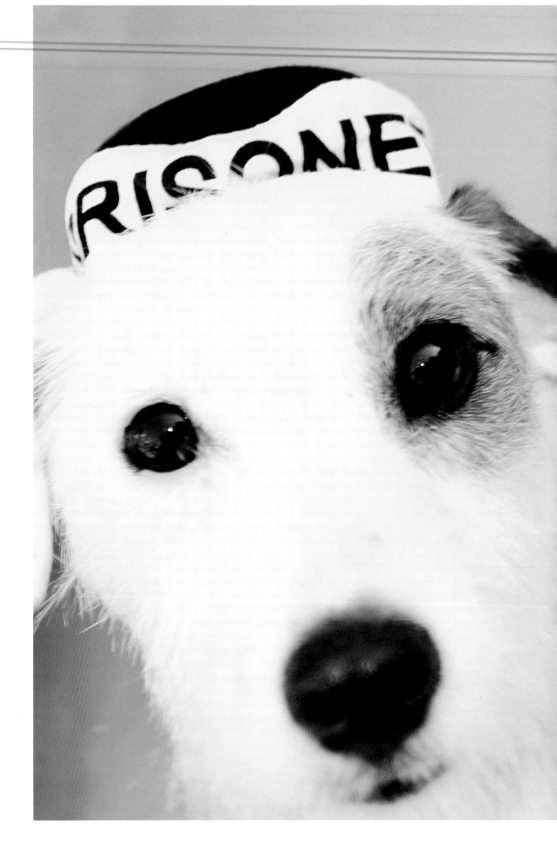

jailbird + jack russell terrier

"A door is what a dog is perpetually on the wrong side of."

OGDEN NASH

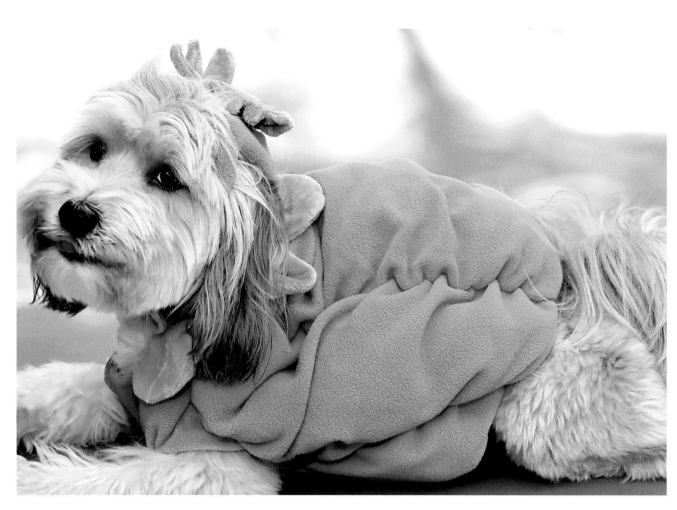

pupkin + tibetan terrier

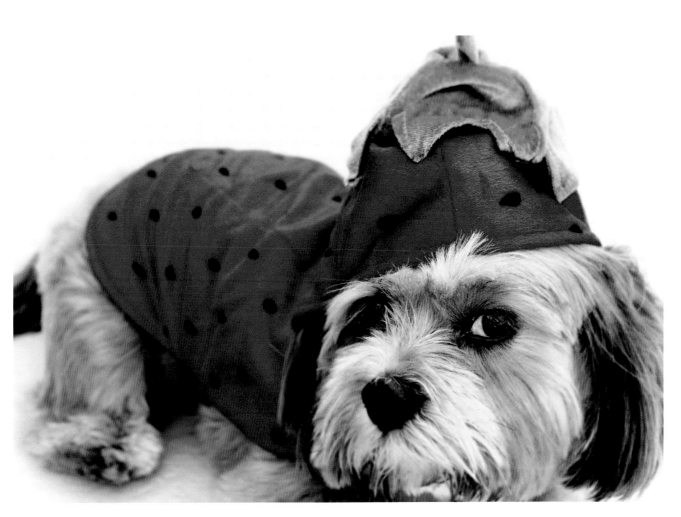

strawberry + lhasa apso

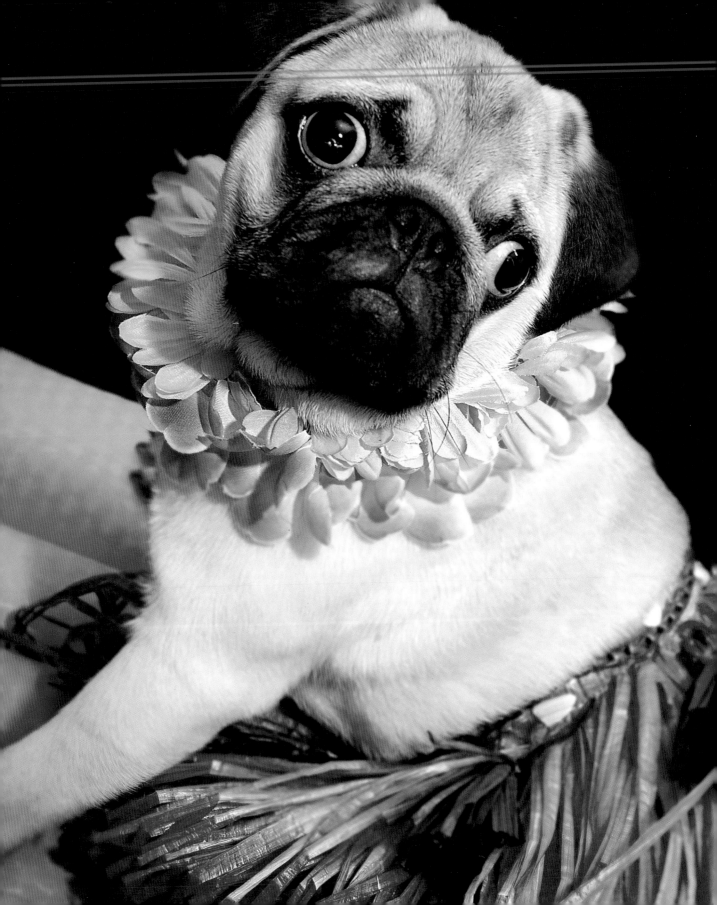

aloha spirit + pug

tomato + beagle

"When in doubt, wear red."

BILL BLASS

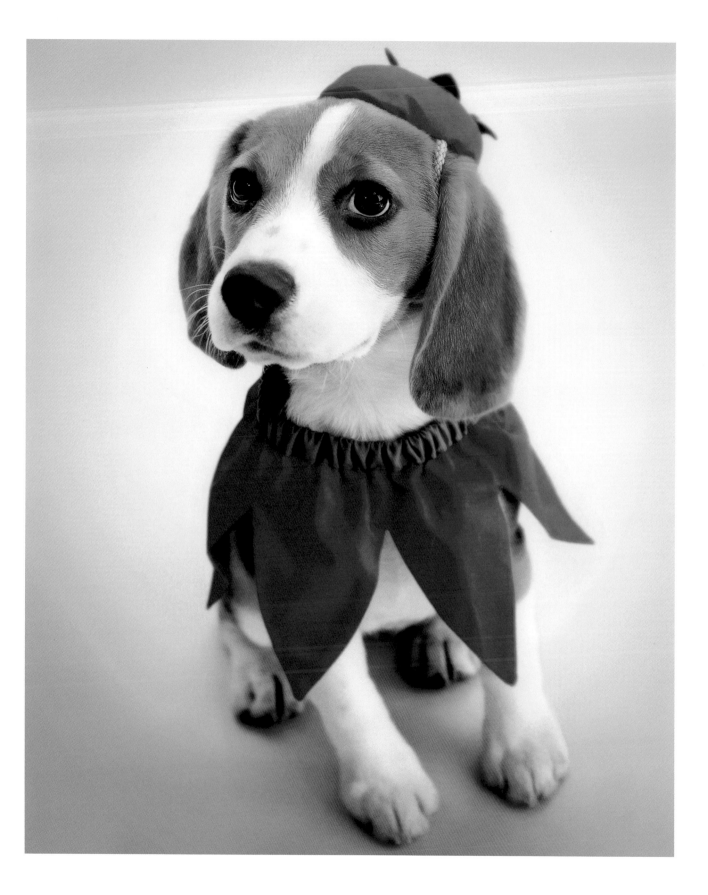

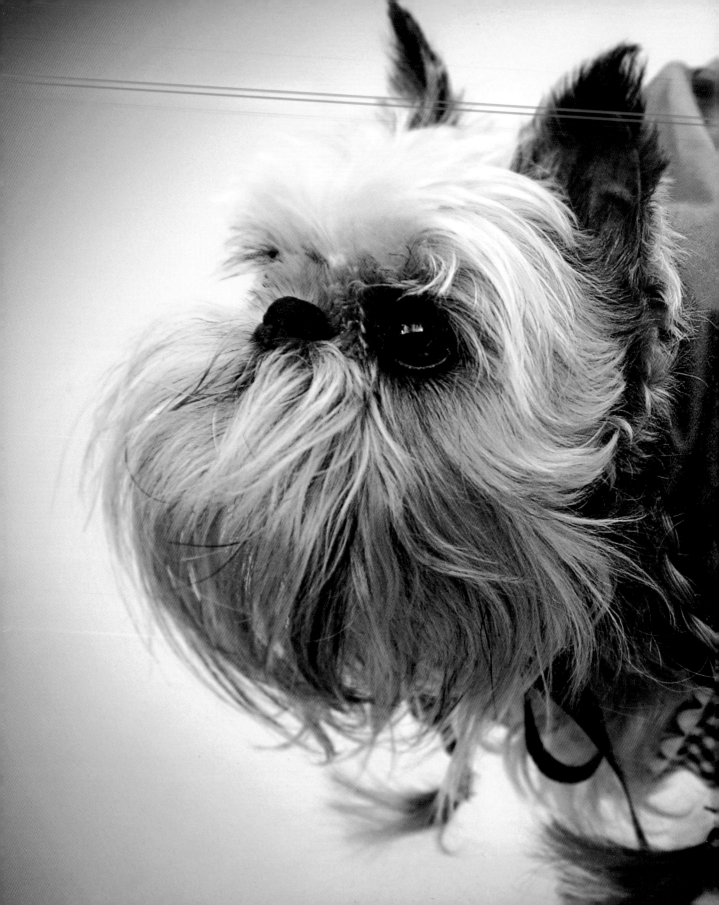

little red riding hood + brussels griffon

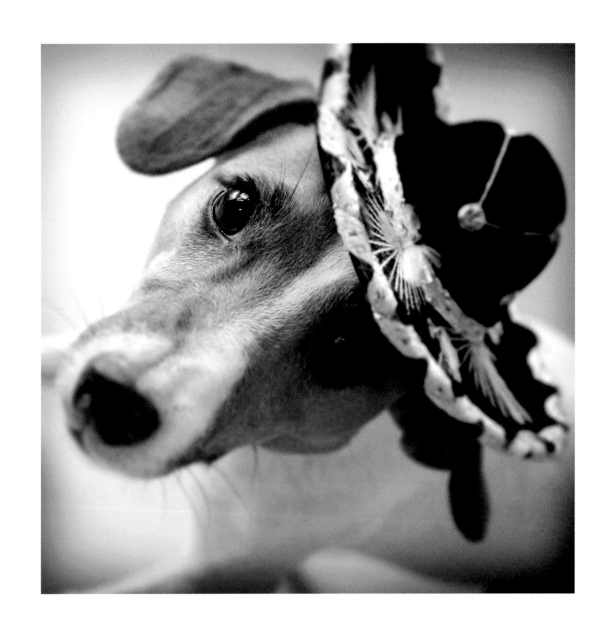

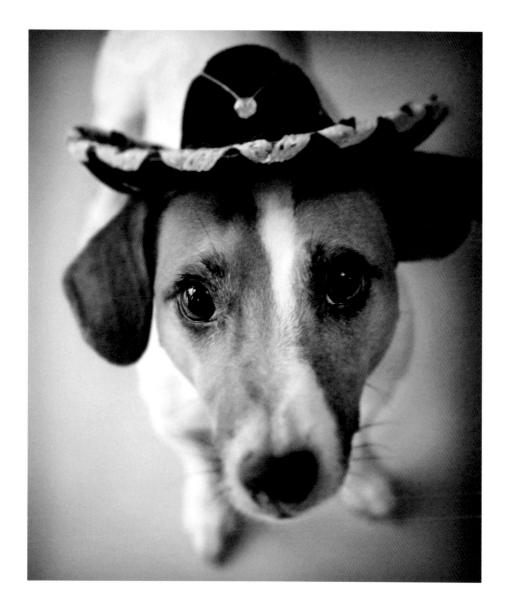

mariachi + jack russell terrier

davy crockett + cairn terrier

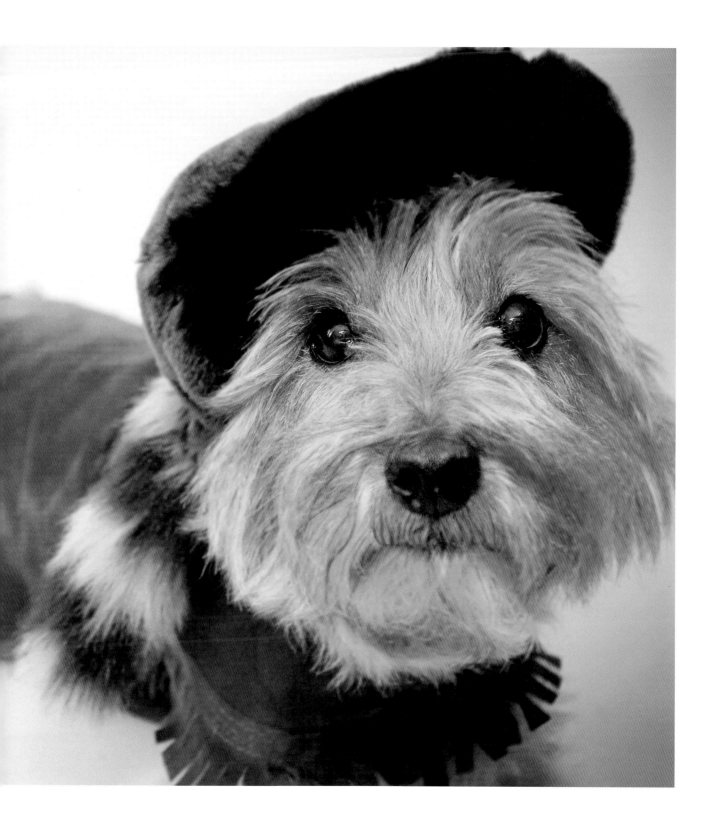

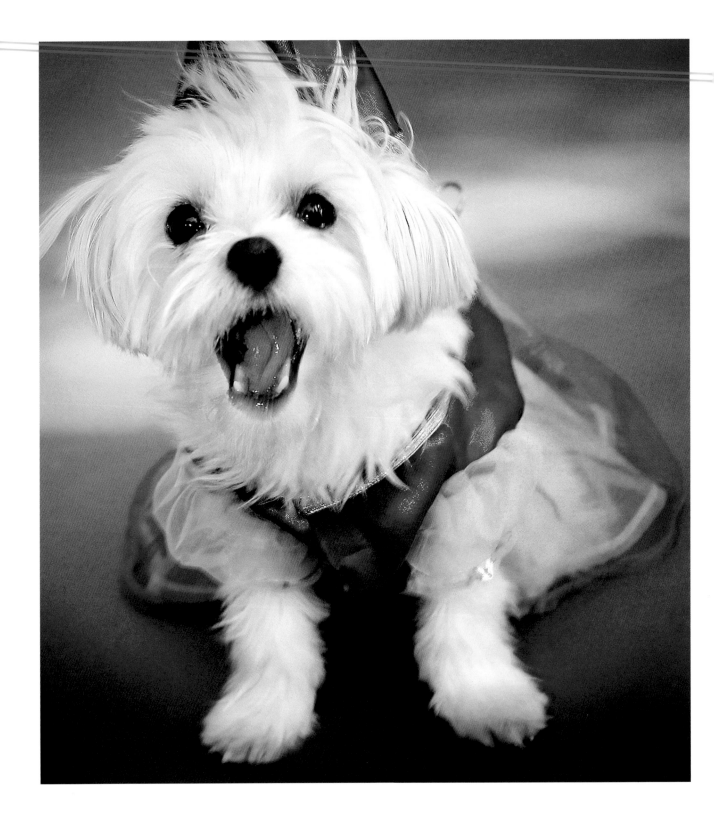

princess + maltese

"It's hard being a princess, but one day I'll be the queen."

ANONYMOUS

peacock + chihuahua

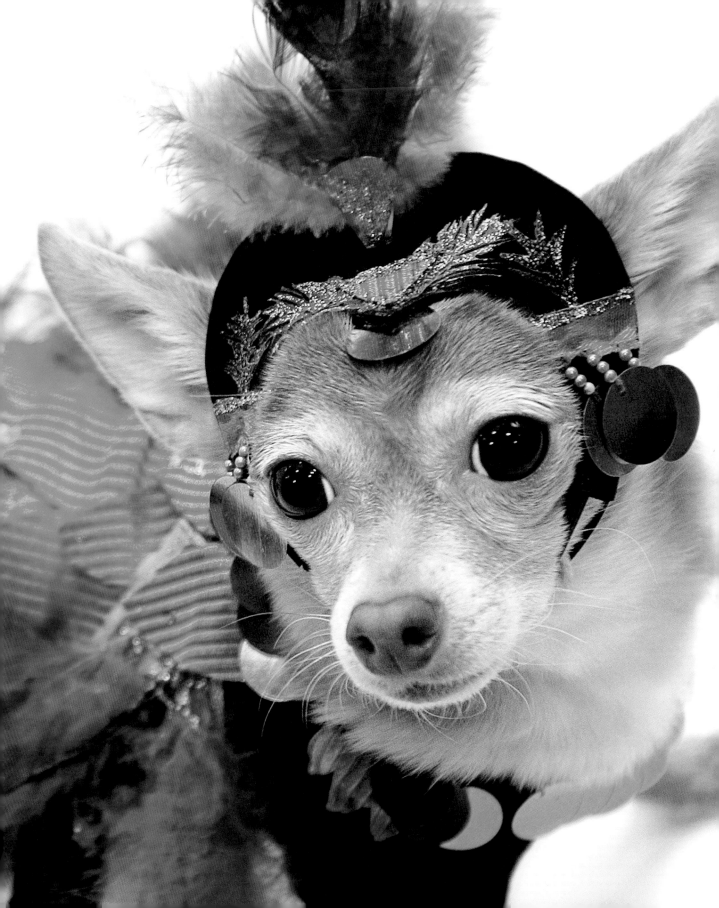

genie + mountain view cur

"Your wish is my command!"

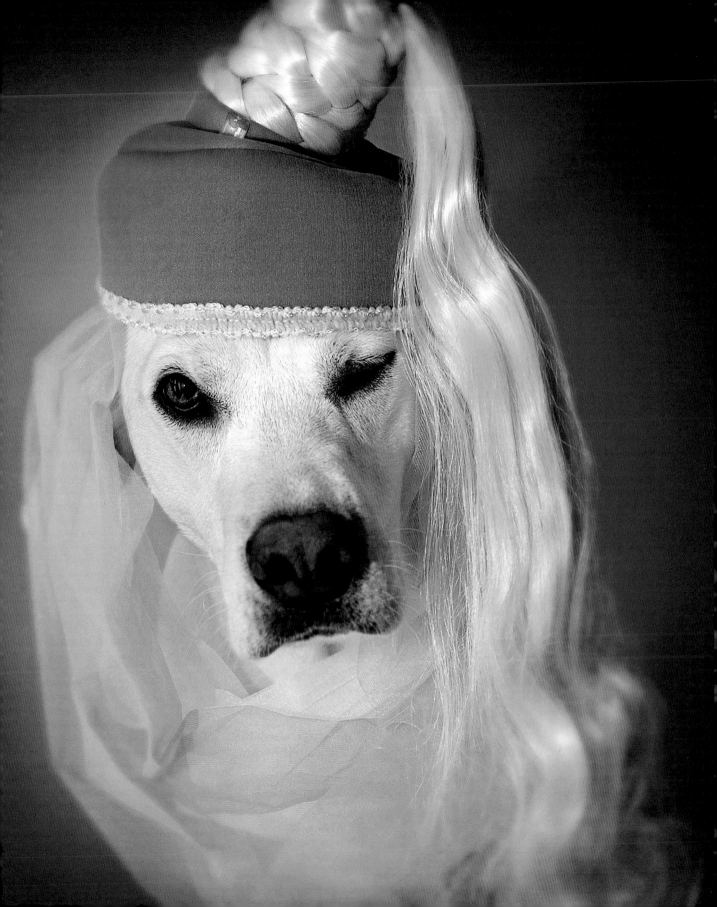

blossom + saluki mix

*"If we could see the miracle
of a single flower clearly,
our whole life would change."*

BUDDHA

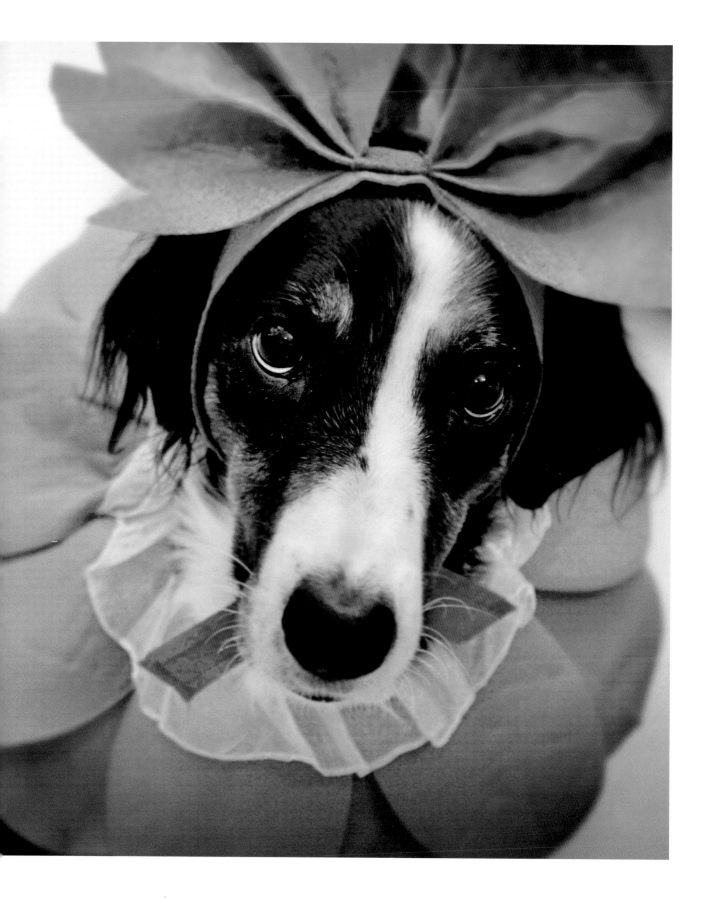

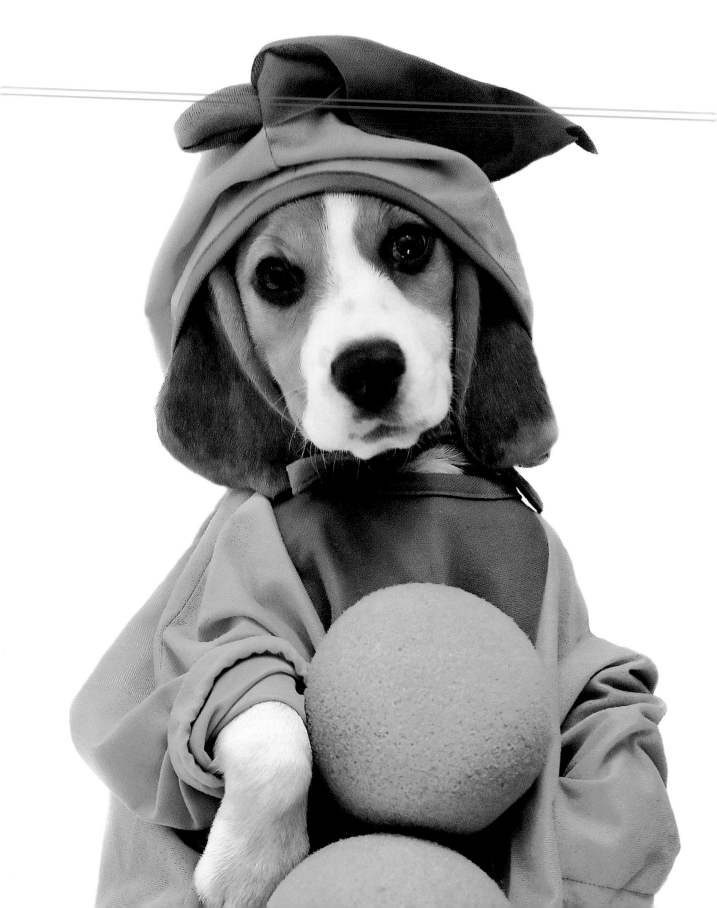

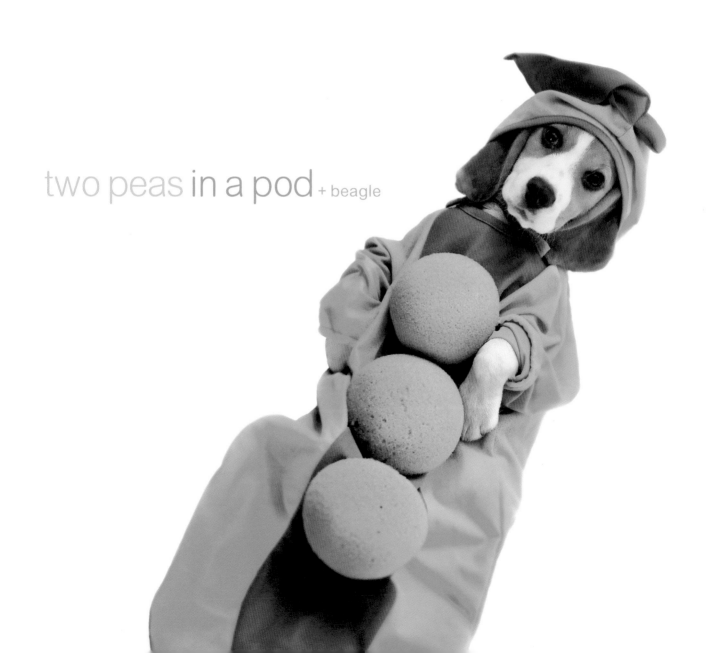

two peas in a pod + beagle

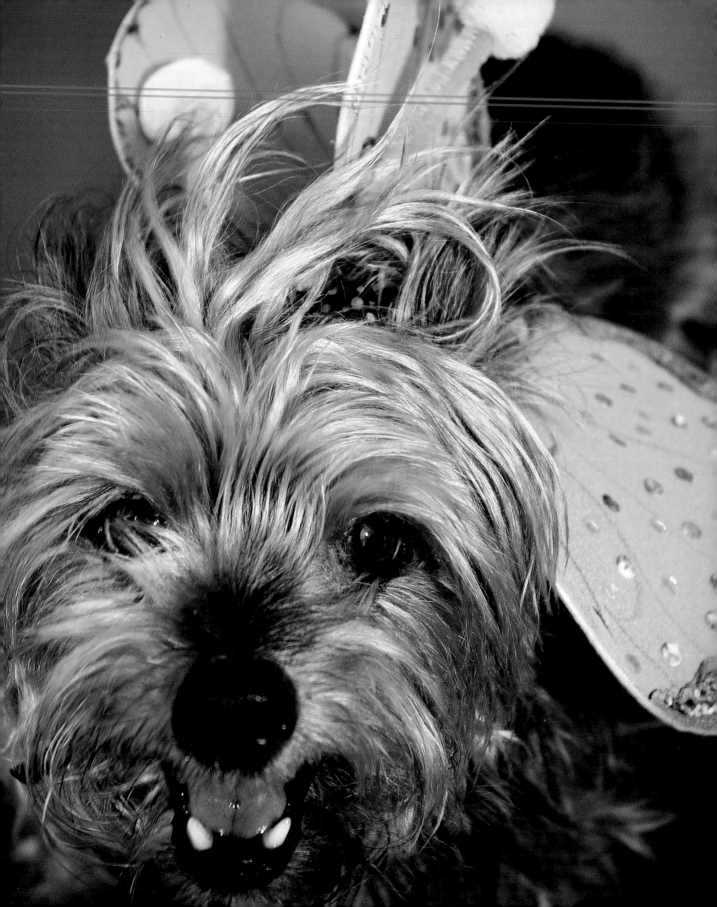

butterfly + yorkshire terrier

"The caterpillar does all the work, but the butterfly gets all the publicity."

GEORGE CARLIN

witch + chihuahua

"I'll get you, my pretty, and your little dog too!"

THE WICKED WITCH OF THE WEST

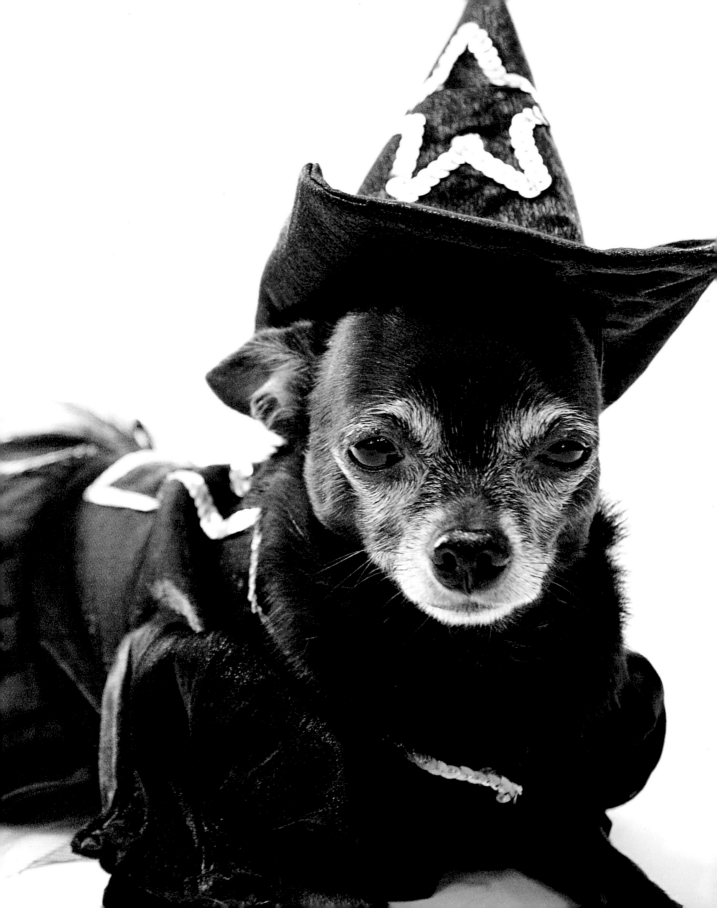

howloween + schnoodle

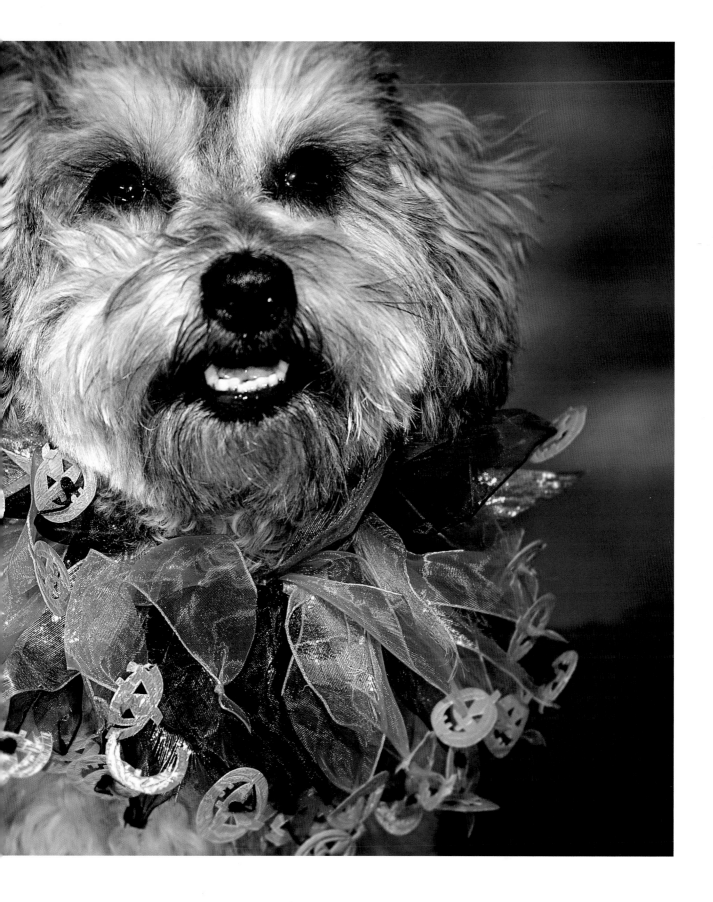

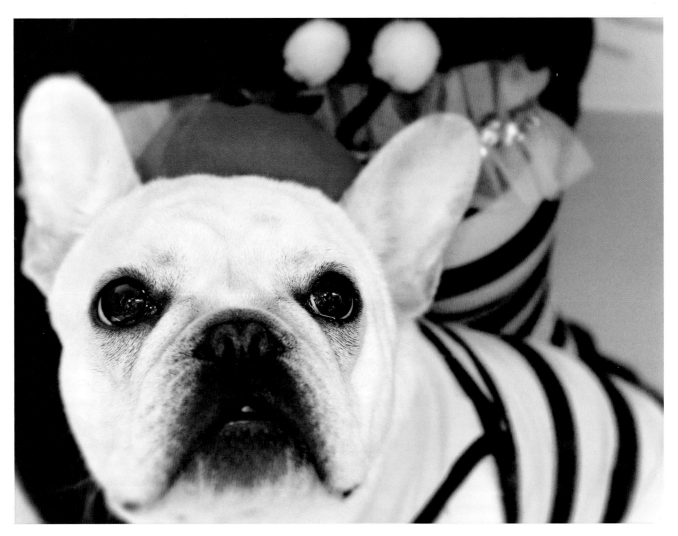

busy bee + french bulldog

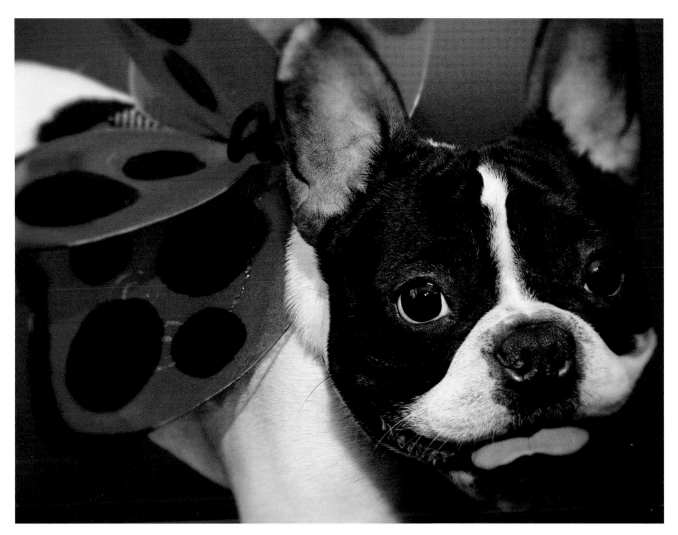

give a hug, ladybug + french bulldog

viva las vegas + chihuahua

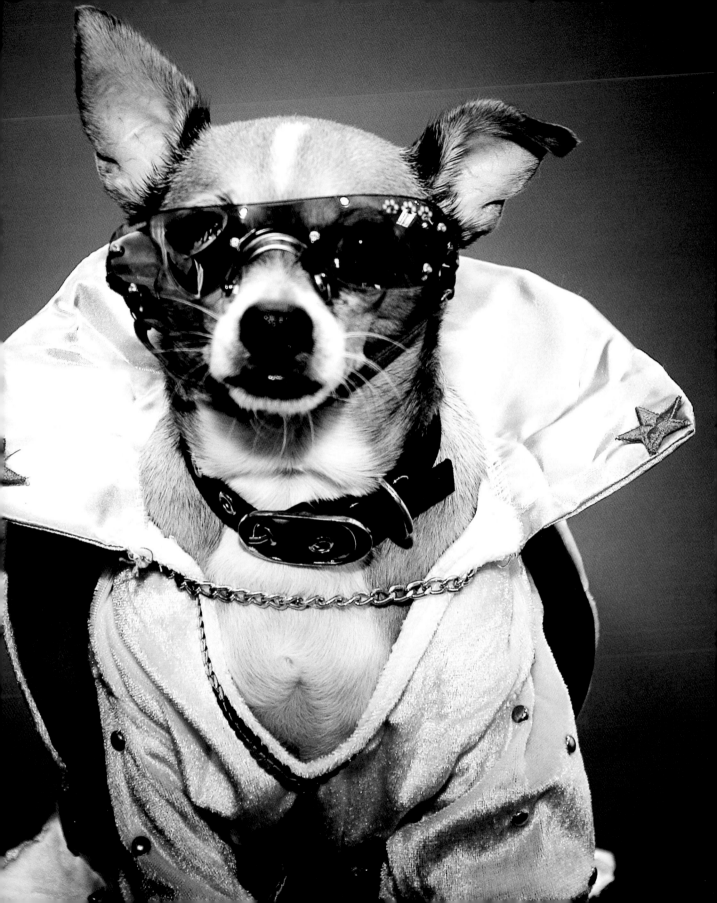

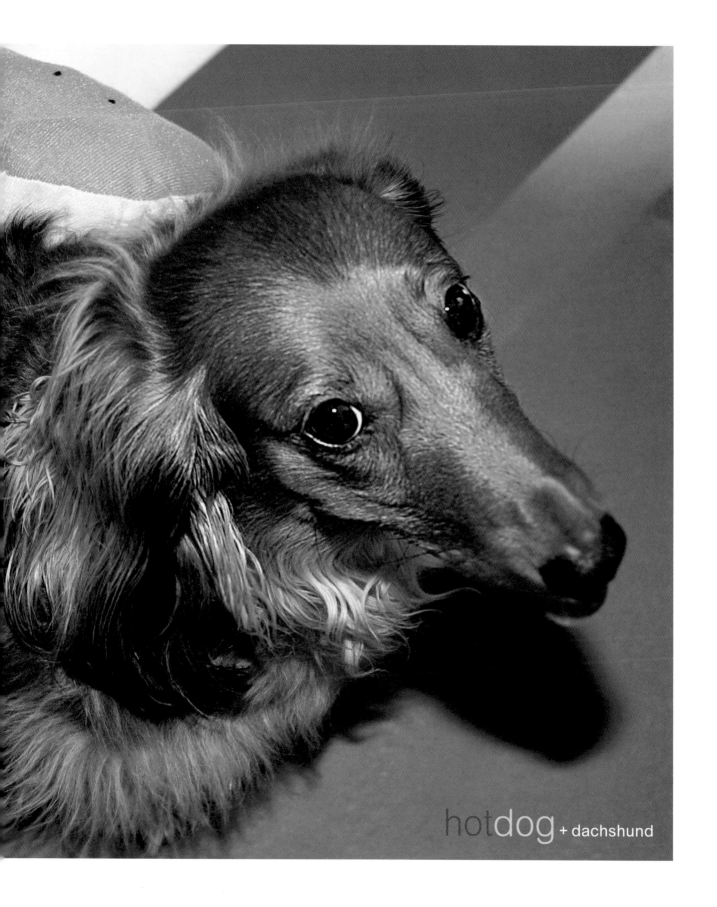

hotdog + dachshund

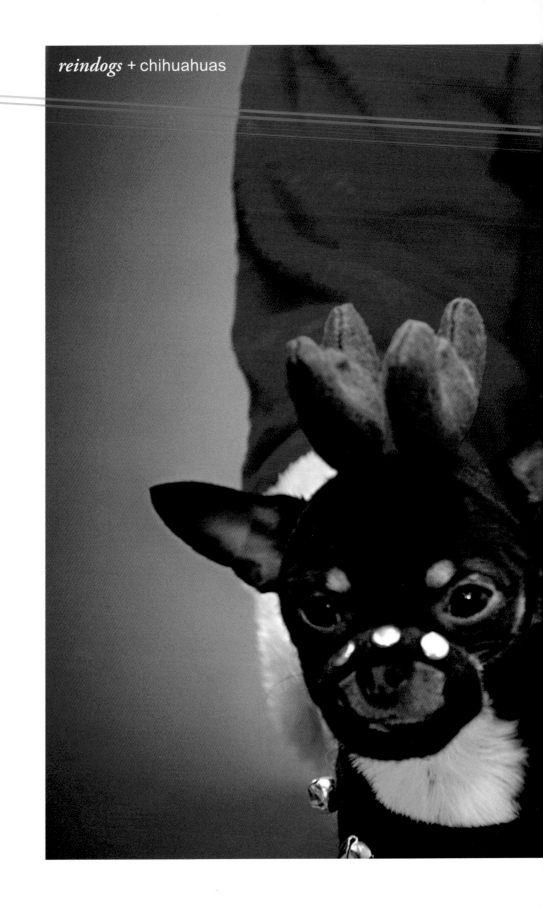

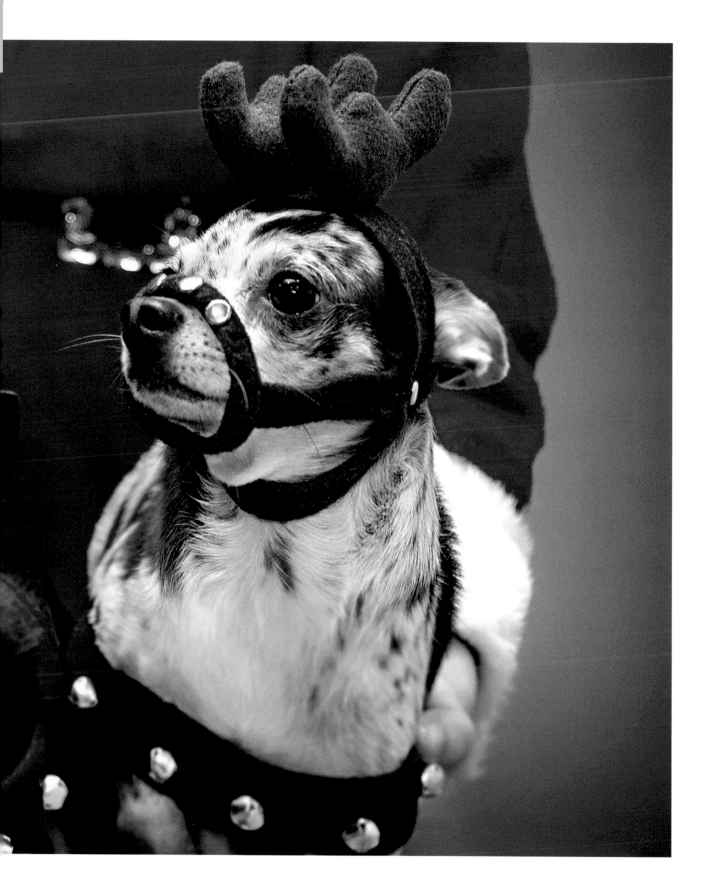

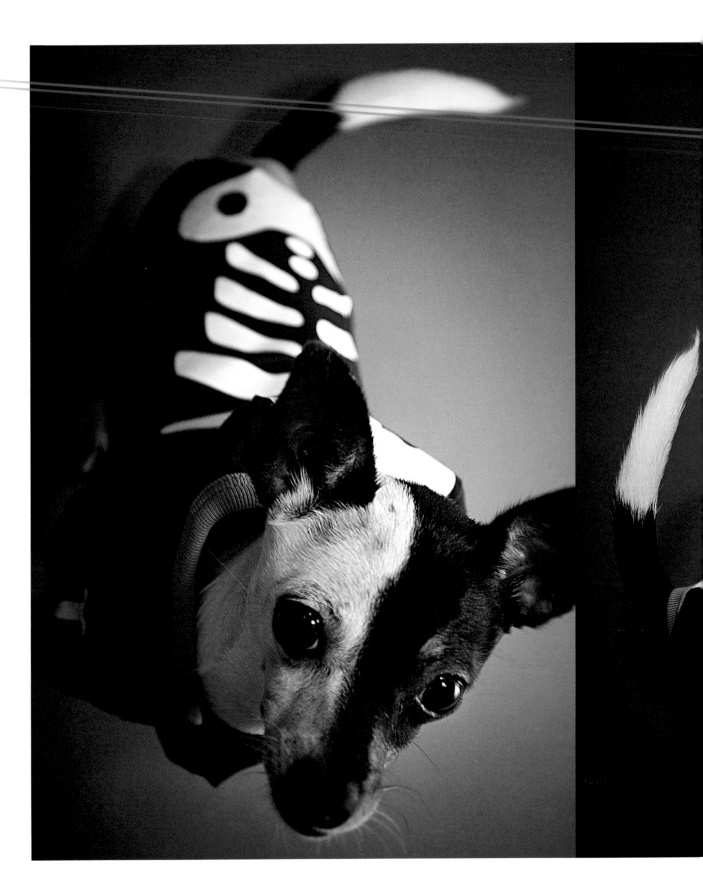

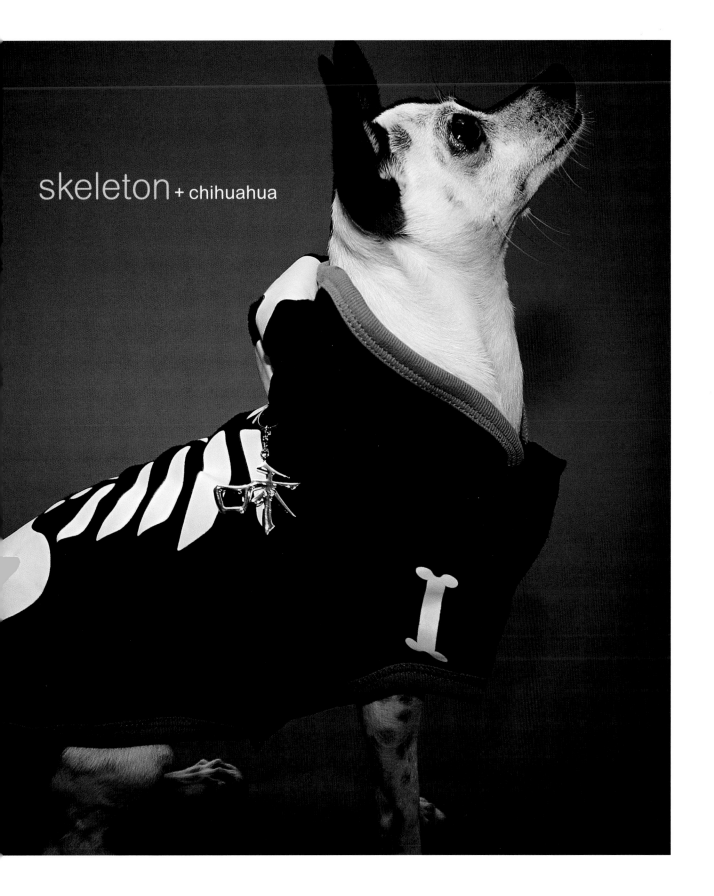

skeleton + chihuahua

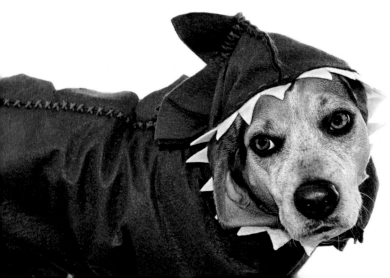

dogzilla + beagle

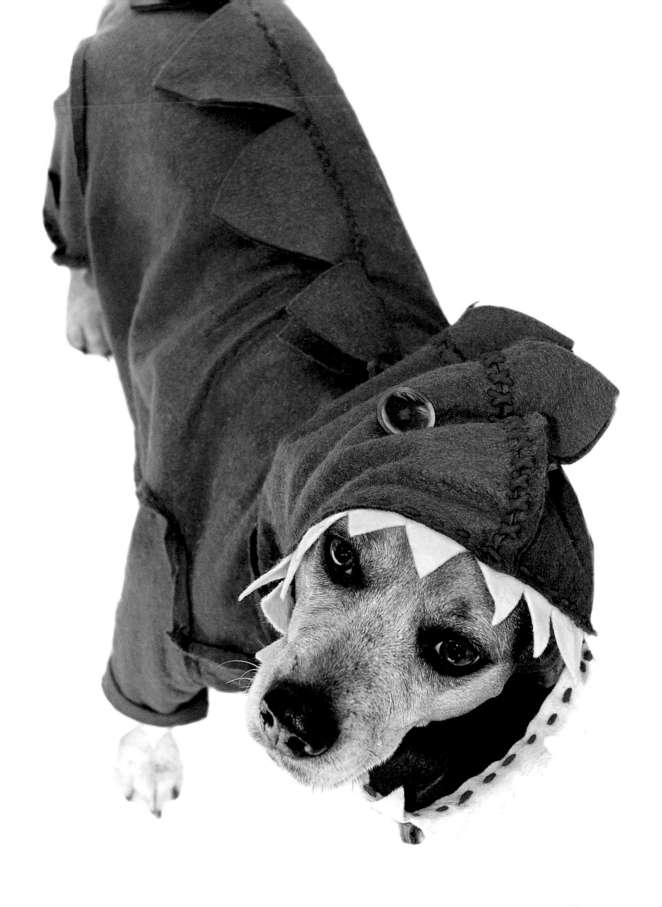

ballerina + pug

"If you can talk, you can sing. If you can walk, you can dance."

AFRICAN PROVERB

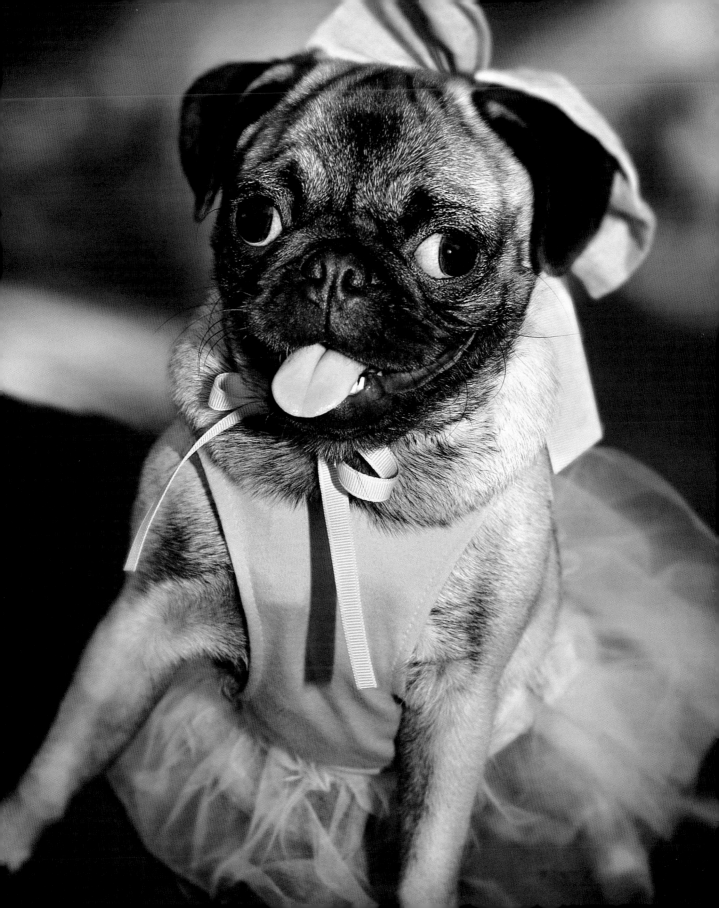

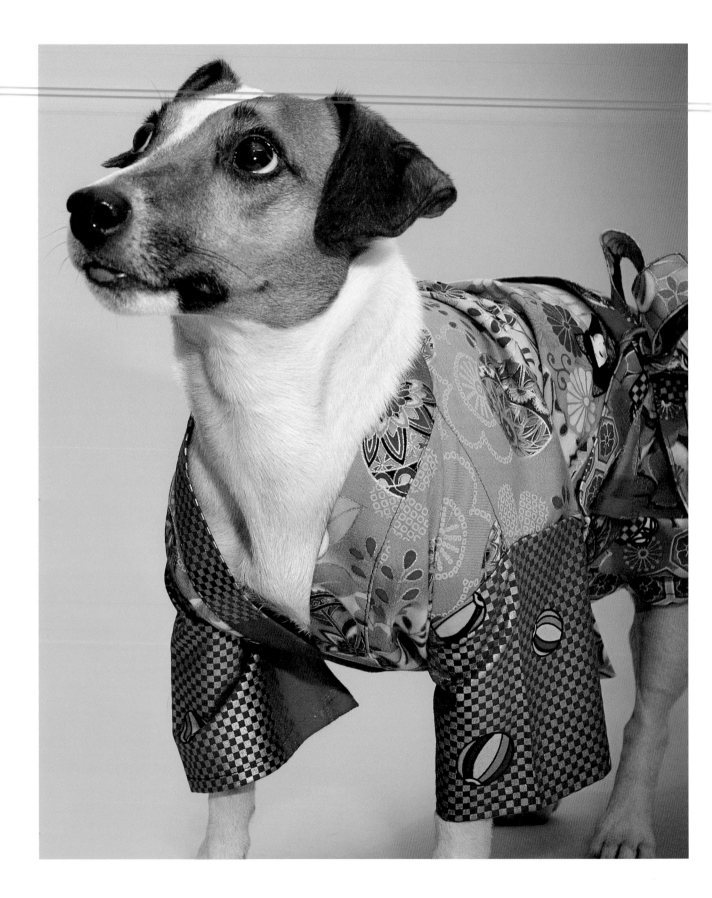

japan + jack russell terrier

"If a man be great, even his dog will wear a proud look."

JAPANESE PROVERB

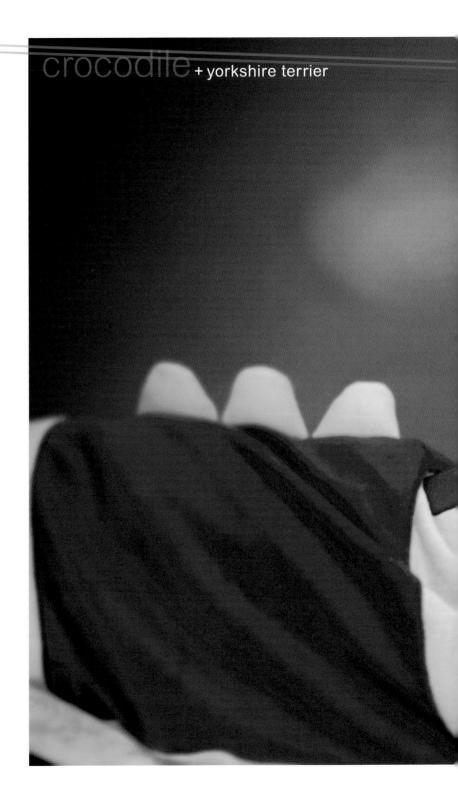

crocodile + yorkshire terrier

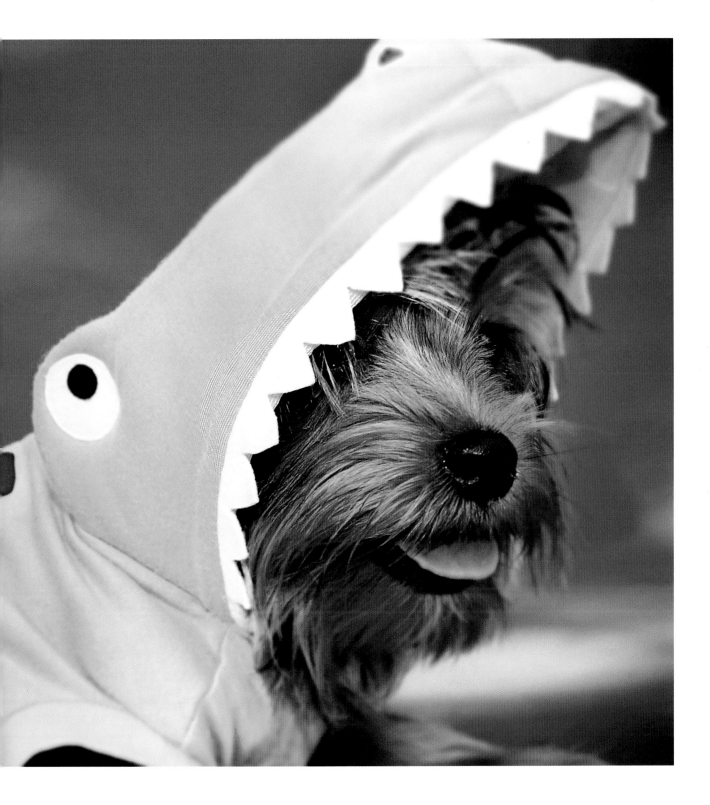

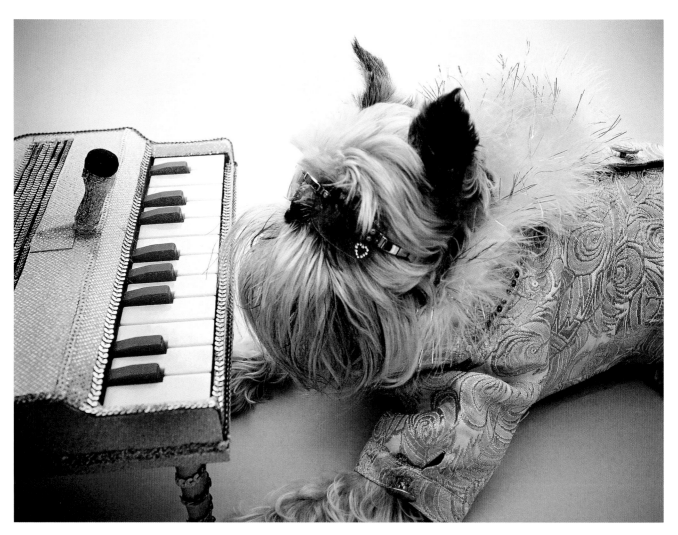

rock star + brussels griffon

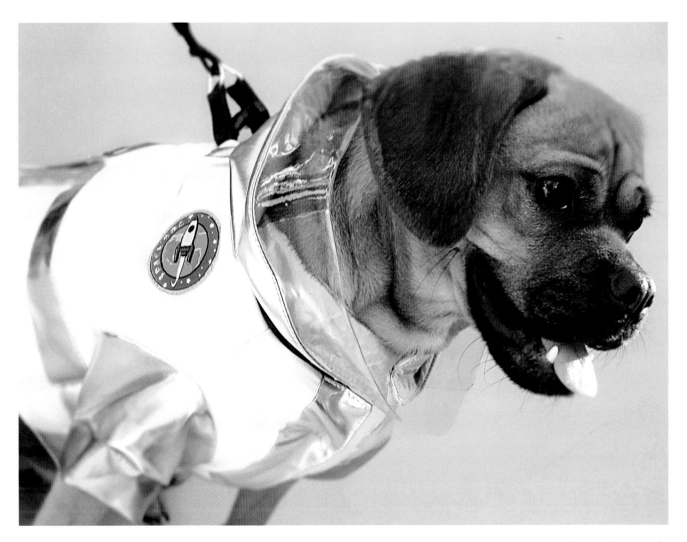

astronaut + puggle

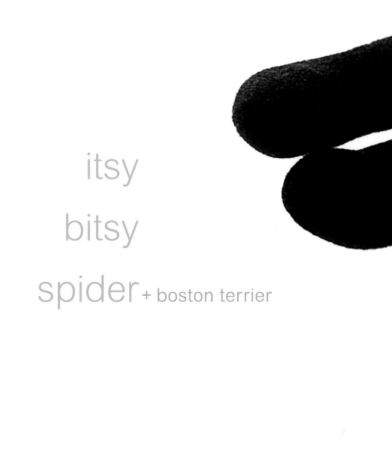

itsy

bitsy

spider + boston terrier

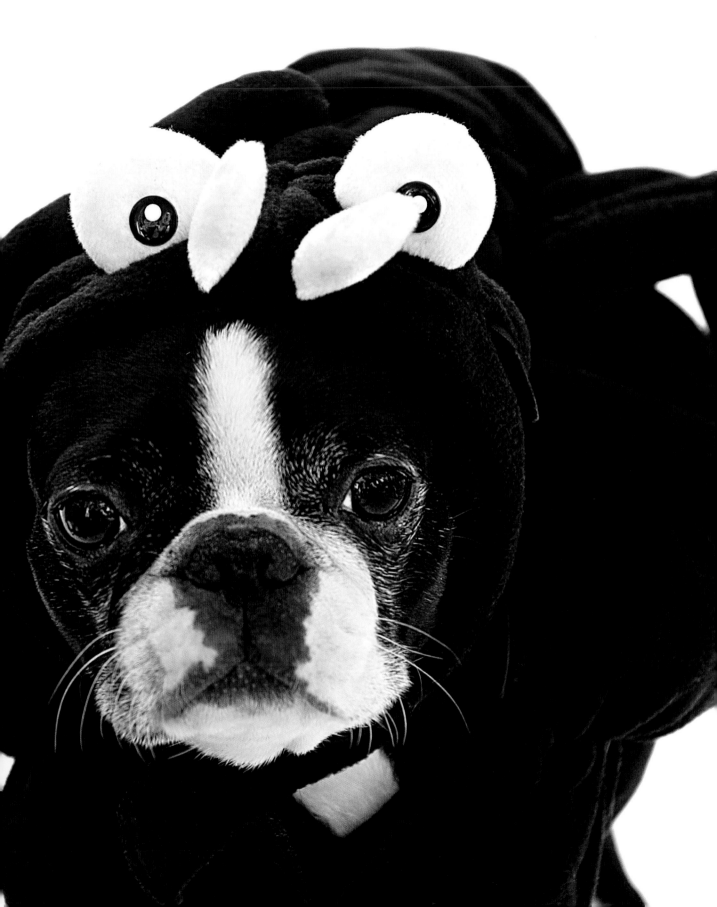

sailor + beagle

"How happy is the sailor's life, from coast to coast to roam;
in every port he finds a wife, in every land a home."

ISAAC BICKERSTAFFE

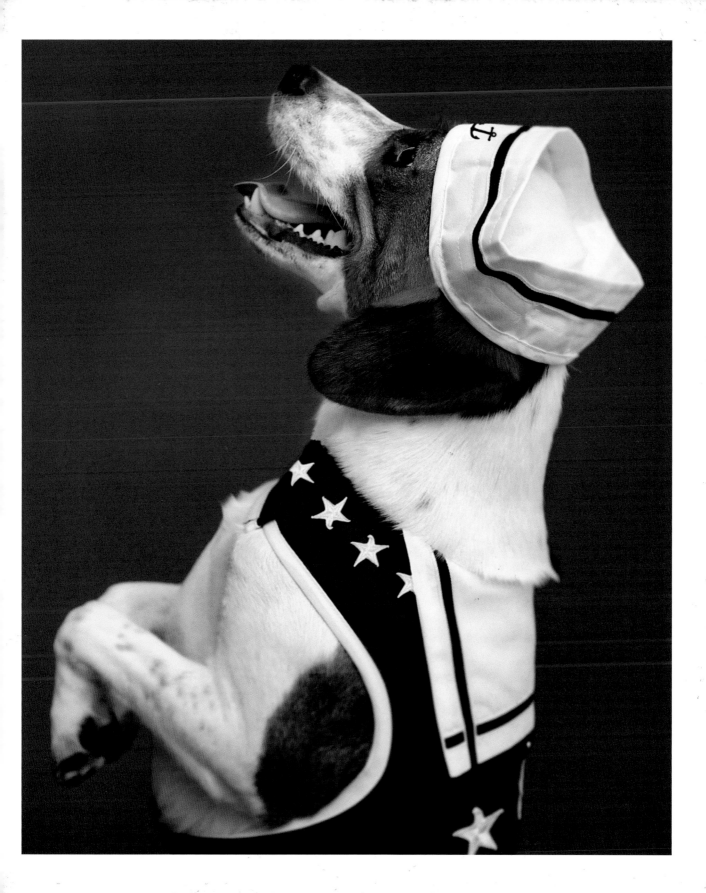

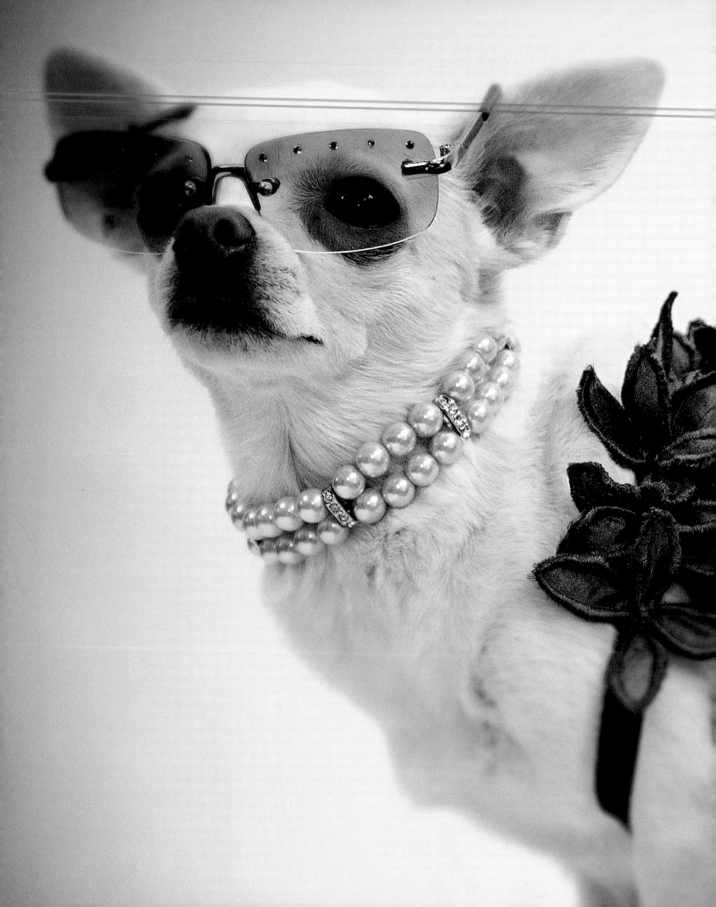

the red carpet starlet + chihuahua

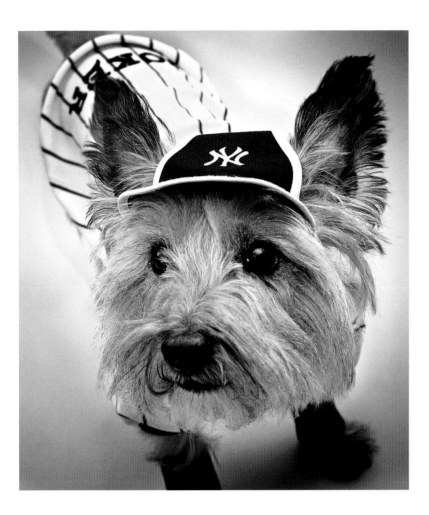

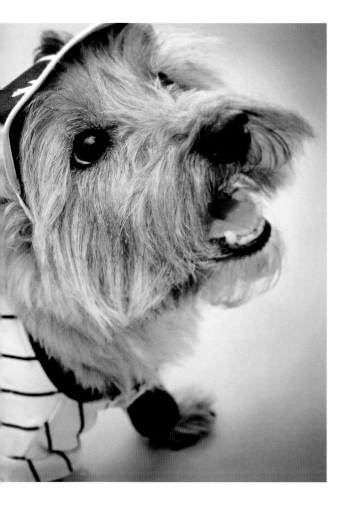
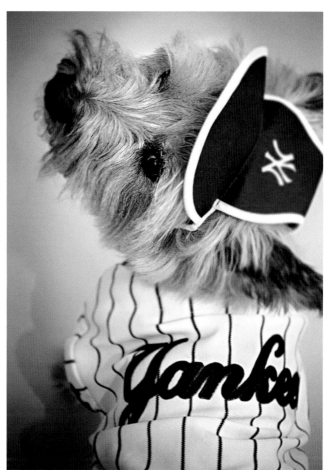

play ball + cairn terrier

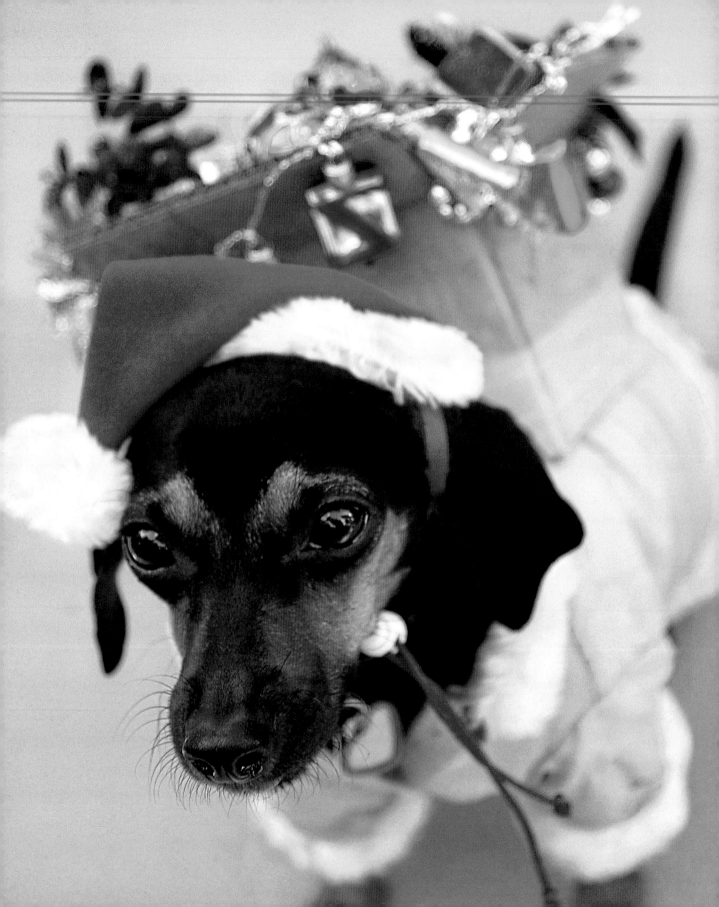

night before christmas + dachshund mix

"No act of kindness, no matter how small, is ever wasted."

AESOP

lobster + brittany spaniel

majorette + brussels griffon

"March to the beat of a different drummer."

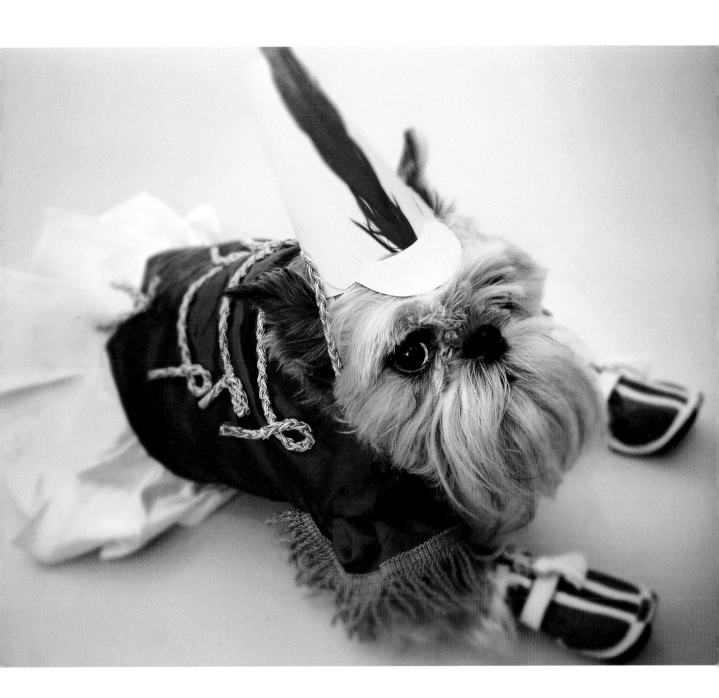

cowgirl + dachshund

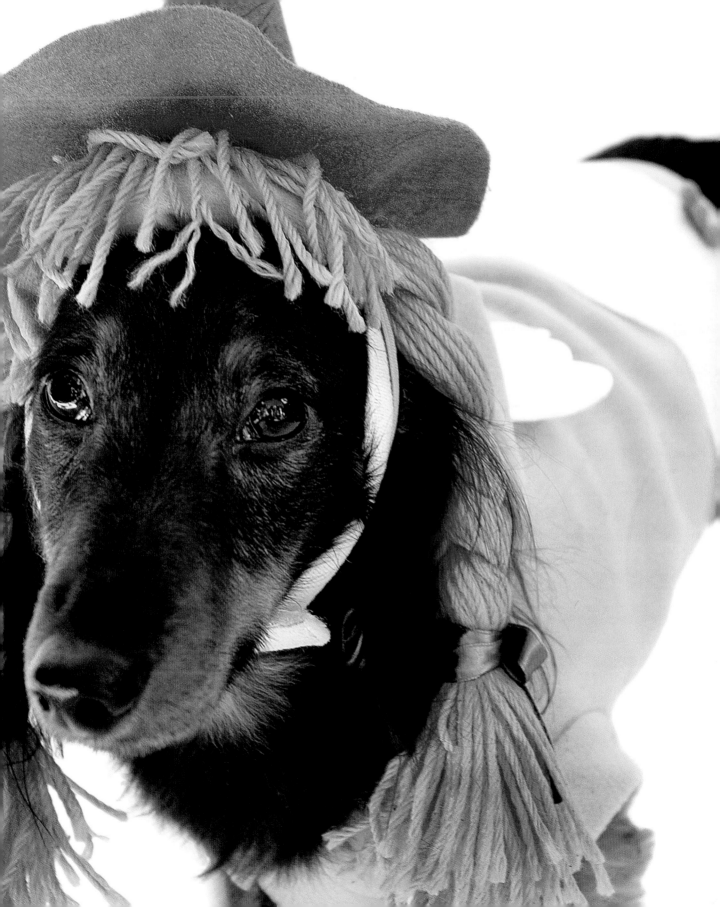

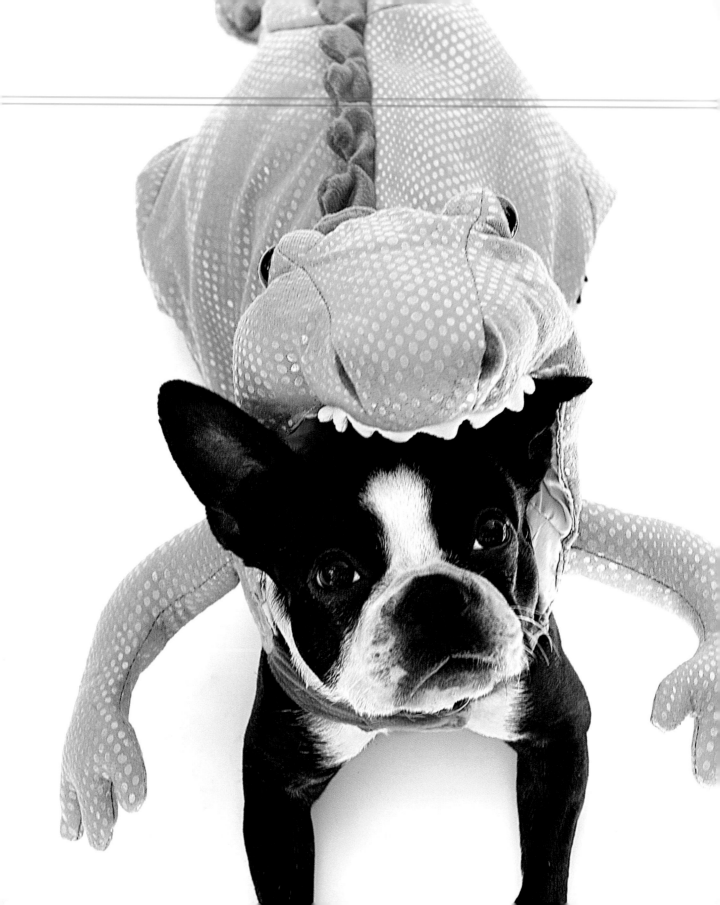

alligator + boston terrier

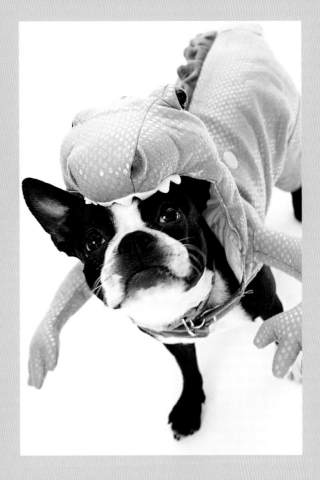

"See you later, alligator. After a while, crocodile."

amelia earhart + foxhound mix

"Fences are made for those who cannot fly."

ELBERT HUBBARD

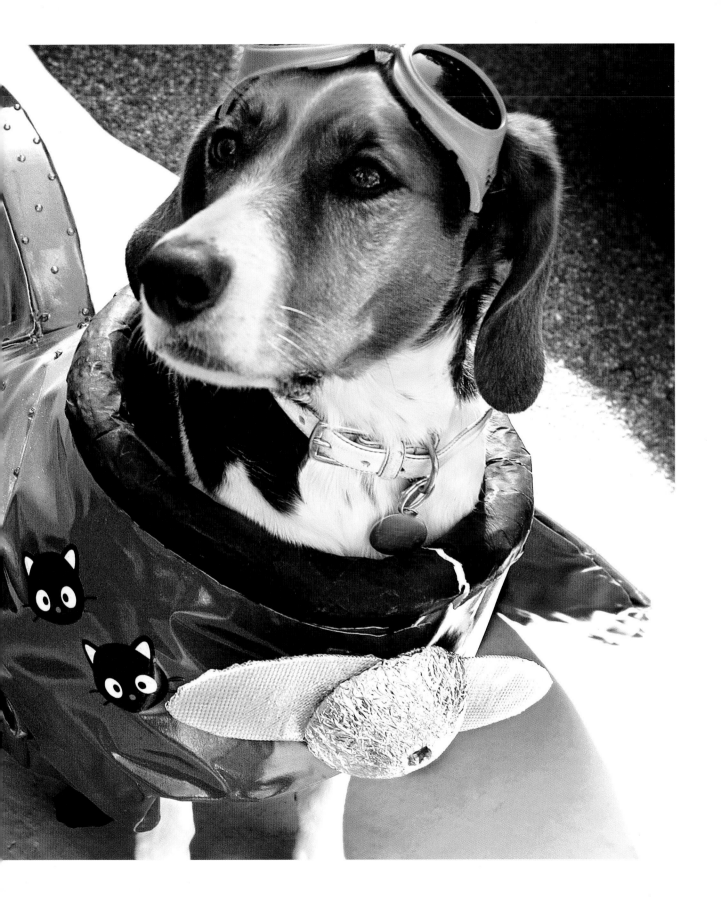

ACKNOWLEDGMENTS

MANY THANKS to my editor, Michael Sand, and the wonderful team at Little, Brown; my agent, Daniel Greenberg; Todd Keithley, for introducing me to Daniel; Christine Hooker and Aaron Sonnenberg, for lending a hand and for their good humor; Beth, for her constant friendship and support; my parents and my little sister; Leslie and John at the now defunct *New York Dog* and *Hollywood Dog* magazines, for giving me my first big break; Garrett and the Tompkins Square Dog Run; the Carl Schurz Park Association; Hannah and Monster Mutt in Brooklyn; FIDO in Prospect Park; Animal Haven; my dog walker, Amy; Ada Nieves; and Martini and Emma.

And thanks to all the lovely dogs featured in this book (and their enthusiastic owners): Mancha, Eli, The Baron Gustav Von Snorticus, Vanilla Salt, Cinnabon Bon, Tequila Bon, Tabasco Chilly Pepper, Sal, Meteor, Mika Bear, Bisou, Bruno, Byrd, Bambi, Puck, Napoleon, Presley, Martini, Emma, Brownie, Gidget, Nino, Sake, Gordon, Winston, Luke, Zelda, Mocha, Jersey, Finnbar Flynn, Tucker, Aria, Spock, Dudley, Zeena, Lola, Quincy, Dooley, Lucille, Dakota, Coco Chanel, Taishan, Beagle, Molly, Tcup, Baxter, Simba, the Jabberwock, Mazie, Brit, Mocha, Twiggy, Bella, and Stitch.

1078769690